HOW TO DRAW
ALMOST EVERY ANIMAL

AN iLLUSTRATED SOURCEBOOK

CHiKA MiYATA

QUARRY

CONTENTS

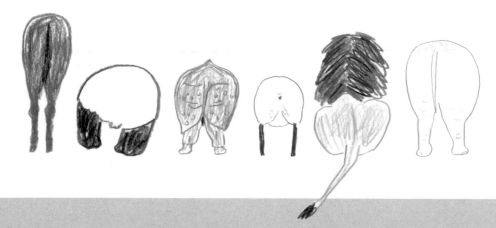

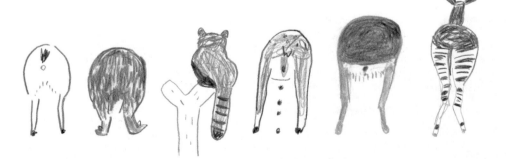

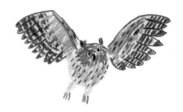

My goal with this book is to help people have more fun and enjoy the process of drawing, not necessarily to teach people to draw well. I often hear people describe their artistic abilities as good or bad, but there's no correct answer when it comes to art.

In nature, each animal is unique, possessing different colors and different shapes. Remember to embrace this when drawing and don't get caught up if the angle of the body is off or the facial features aren't in proportion.

I've included step-by-step illustrations to help you get started drawing your favorite animals. Whether you're a young artist just starting out, or a more experienced artist interested in learning something new, I hope that you'll discover how fun and easy drawing animals can be!

Chika Miyata

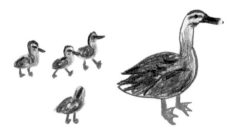

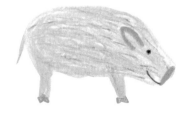

MATERIALS

ROYAL TALENS VAN GOGH COLORED PENCILS

These soft-leaded colored pencils produce beautiful, smooth lines. The colors remain brilliant, even when mixed.

STAEDTLER ERGOSOFT COLORED PENCIL

These pencils feature a specially coated lead, so you can draw with a sharpened point without worrying about breakage.

KNIFE

Using a knife to sharpen colored pencils allows you to adjust the shape and thickness of the lead according to your personal preferences. I have a special whale-shaped knife.

MUJI COLORED PENCILS

Made of cedar, these pencils feature strong, durable leads. They are great for sketching animals out in the wild.

FABER-CASTELL POLYCHROMOS COLORED PENCILS

This is my favorite black colored pencil. Sharpen the tip and use this pencil to draw fine details like eyes and noses.

MARVY UCHIDA LE PLUME PERMANENT MARKER

The white marker from this set is opaque and pigmented, making it great for adding white details on top of dark backgrounds.

HOLBEIN ARTISTS' COLORED PENCILS

Available in 150 different shades, these colored pencils offer great variety. Colors appear brilliant, even when only light pressure is applied to the pencil.

STAEDTLER ERGOSOFT JUMBO COLORED PENCILS

With extra thick leads, these pencils are great for coloring large areas. These chunky, hexagonal pencils are designed for children's hands.

LIQUITEX PROFESSIONAL PAINT MARKER

I used this pigment marker to add white spots and stripes to animals with dark fur. It produces a thicker line than the Le Plume marker.

LET'S PRACTICE DRAWING

PRACTICE DRAWING WITH COLORED PENCILS

All of the drawings in this book were created using colored pencils (plus a couple markers for details). Let's try drawing a few different types of lines.

Now let's use those lines to draw a sleeping capybara:

1 Outline the capybara's body using the tip of the pencil

Tilt the pencil and use the side of the lead to fill the body with color.

2 Fill the body with color

Wasn't that easy? Zzzz...

3 Add the ear, eye, and nose

4 Use short, dashed lines to add hair to the body

PRACTICE DRAWING DIFFERENT TYPES OF LINES

All of the animals in this book are drawn with a combination of a few simple lines and basic shading techniques. Let's learn how to make the lines you'll need to draw animals.

FILLING
Tilt the colored pencil and use the side of the lead to fill an area with color. This technique is great for animals with short hair.

WAVES
Use wavy lines for the soft feathers of birds.

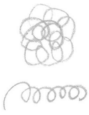

SPIRALS
Use spiral lines for animals with voluminous, curly fur.

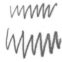
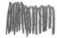

ZIGZAGS
Use zigzag lines for animals with thick, short fur.

DASHES
Use short, dashed lines to create the impression of fluffy fur or short, thick feathers.

 Stripes

 Dots

HOW TO DRAW PATTERNS
Many animals have distinctive markings. To recreate these patterns in your drawings, first color the animal with a base color. Next, add stripes, dots, or other lines on top.

USE LINES TO DRAW ANIMALS

Now it's time to put it all together! Combine these lines to draw different animals.

SQUIRREL

Use short, dashed lines to capture the fluffiness of a squirrel's tail and tummy.

ALPACA

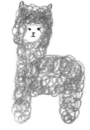

Use spiral lines for an alpaca's curly hair.

BROWN BEAR

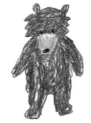

Use zigzag lines for a bear's thick fur.

OSTRICH

Use the side of the pencil lead to fill in the ostrich's neck.

Use big, wavy lines for an ostrich's wings.

Use big zigzag lines to cover the ostrich's body with feathers.

CHEETAH

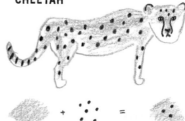

Use the side of the pencil lead to fill the cheetah's body with short fur, then add black spots.

HOW TO USE THIS BOOK

IF YOU WANT TO LEARN ABOUT ANIMALS

Looking for a certain animal? You'll find each animal's name at the top of the page. As an added bonus, you can learn some interesting facts about each animal while you practice drawing.

KANGAROO · · · · · · · · · · · Common name

· · · · · · · · · · · · · · · · · · ·
Scientific Name: *Macropus* · · · · · · · Scientific name
· · · · · · · · · · · · · · · · · · ·

IF YOU WANT TO KNOW HOW TO DRAW ANIMALS

Step-by-step illustrations are included to show you how to draw each animal from start to finish. Use these guides to practice drawing the animals yourself. Don't worry if you mess up, just keep going!

 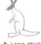

1 Bean-shaped face and long bunny ears **2** Bent arm and gentle curve for back **3** Big, strong foot **4** Long, thick tail that touches ground

5 Color with brown, using a slightly darker shade along back **6** Add eye, nose, and claws

IF YOU NEED SOME INSPIRATION

I've included lots of images for each animal: different poses, different species, and different ages. These alternative images are meant to inspire and offer ideas and techniques for your own drawings.

LION

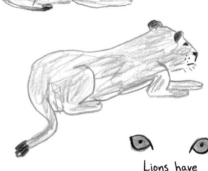

- -

Scientific Name: *Panthera leo*

- -

Lions are sociable animals that live together in groups called prides. Lions sleep for up to 20 hours a day, then hunt when they get hungry.

Lions have excellent night vision!

Black pores for the whiskers

White chin and tummy

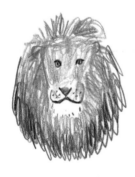

AFRICAN LION

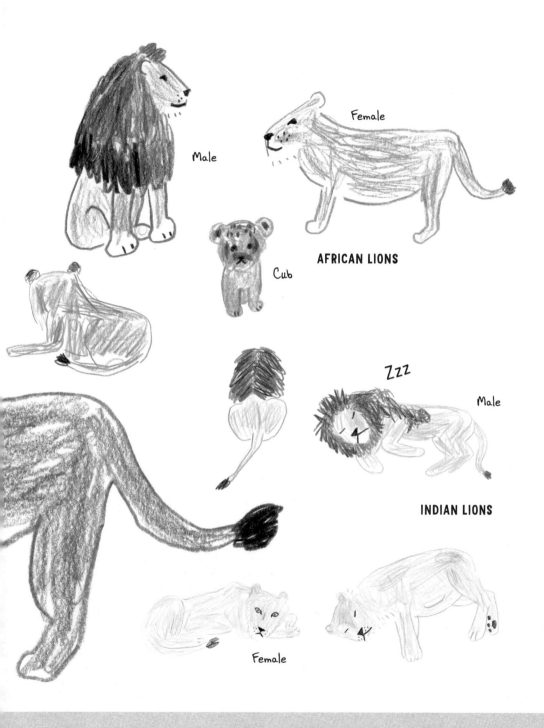

Male

Female

Cub

AFRICAN LIONS

Zzz

Male

INDIAN LIONS

Female

1 Small semicircle for ear and a wide L-shape for head

2 Short lines for chin whiskers

3 Triangle nose

4 Curved line for mouth and a short line for an eye closed in sleep

5 Or try a triangle-shaped eye for a wide-awake lion

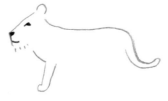

6 Smooth curve for back and tail, plus a thick front leg

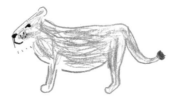

7 Female lion: Color entire body brown, except for chin and tummy

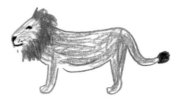

8 Male lion: Add a mane and furry tail

TIGER

Triangular or half-moon-shaped eyes

Scientific Name: *Panthera tigris*

Tigers are the largest wild cats in the world. Easily recognized by their striped coats, tigers are powerful predators.

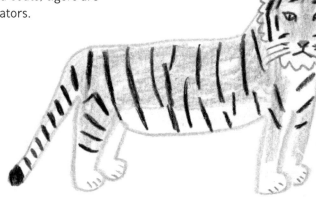

Pink nose

Black tail tip

1 Two semicircles for ears

2 Wavy lines for cheeks

3 Color center of face orange, leaving sides white

4 Add eyes, nose, mouth, and whiskers, then draw stripes on forehead and cheeks

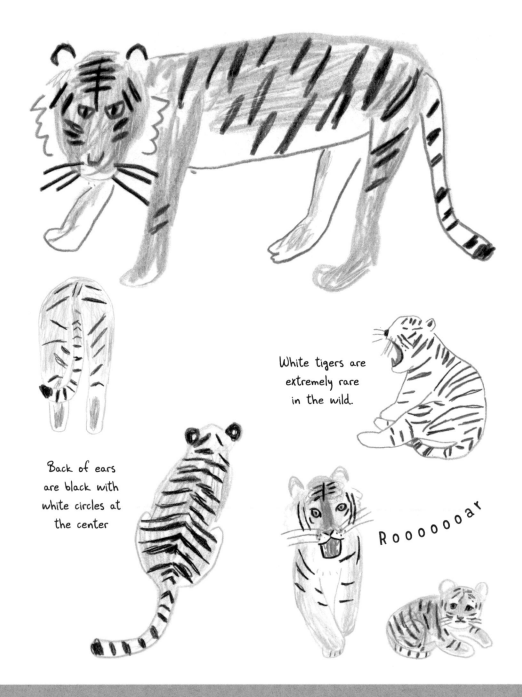

White tigers are
extremely rare
in the wild.

Back of ears
are black with
white circles at
the center

Rooooooar

 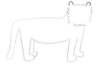

1 Two semicircular ears, then outline face with wavy lines

2 Flat back and long, slightly curved tail

3 Legs with rounded paws

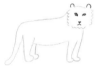 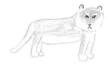 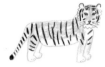

4 Eyes, nose, and mouth

5 Orange body and face with white undersides

6 Add black stripes and whiskers

SIBERIAN TIGER

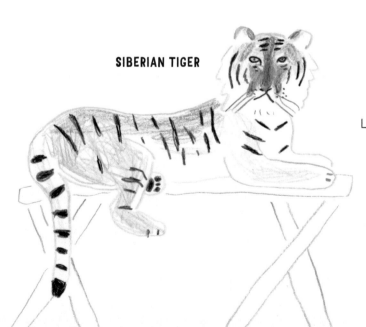

CLOSE UP
Leave the chin and tummy white.

LEOPARD

Scientific Name: *Panthera pardus*

A leopard's trademark spots are the perfect camouflage for hiding among the foliage of their habitat.

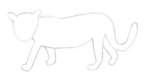

1 Small face with square chin

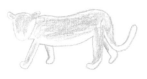

2 Dip in the back and a curvy rump and tail

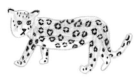

3 First set of legs with round paws

4 Second set of legs shorter for depth

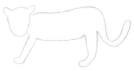

5 Color entire body, leaving undersides white

6 Draw facial features, add black to tips of ears, then draw spots

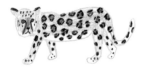

7 Color inside of spots brown

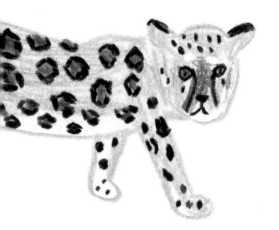

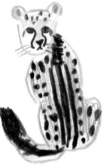

The rare King Cheetah exhibits a unique blotchy fur pattern.

SIMILAR ANIMALS

Cheetah

Cheetahs are the fastest land animals in the world—they can reach speeds of 70 mph (113 kph)!

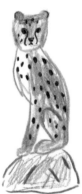

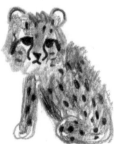

Cheetah cubs have fluffy fur.

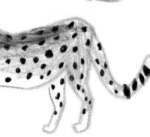

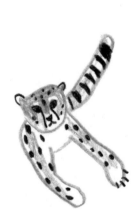

Small face

Snow Leopard

Snow leopards have a white coat with black and brown spots.

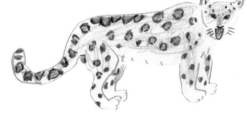

Jaguar

Jaguars looks similar to leopards, but they have larger spots featuring black dots at the center.

Surprisingly, these cats are good swimmers!

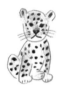

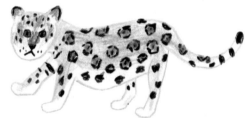

Puma

Pumas are born with spots, but they'll fade away as the cub grows up. Adult pumas have solid brown fur.

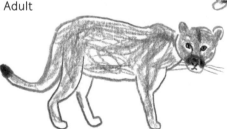

BROWN BEAR

Scientific Name: *Ursus arctos*

Often called grizzly bears, brown bears are the most widely distributed species of bear in the world. Brown bears eat up to 90 pounds of food a day when preparing for hibernation.

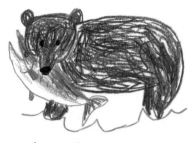

Loves salmon

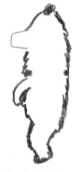

1 Small, rounded ear and curved line for forehead

2 Square-shaped snout

3 Body with heavy, overlapping lines for thick fur

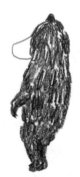

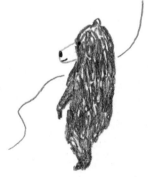

Short tail

4 Vertical zigzags to color in fur

5 Add an eye, nose, and mouth

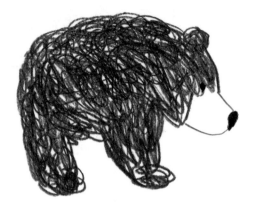

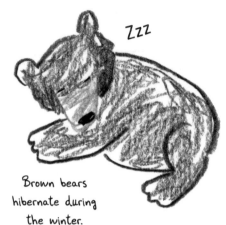

Zzz

Brown bears
hibernate during
the winter.

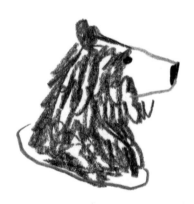

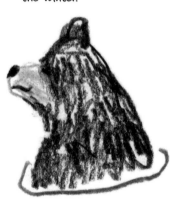

1 Two semicircles
connected
with a line

2 Outline face
with zigzags

3 Color
face brown

4 Cup-
shaped snout

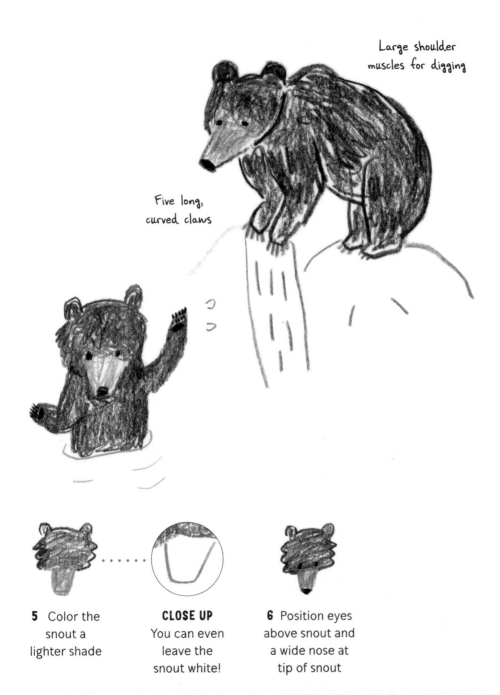

Large shoulder muscles for digging

Five long, curved claws

5 Color the snout a lighter shade

CLOSE UP You can even leave the snout white!

6 Position eyes above snout and a wide nose at tip of snout

SIMILAR ANIMALS

Malayan Sun Bear

Sun bears are named for the unique bib-shaped gold patch on their chests.

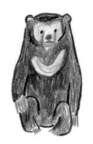

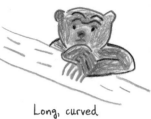

Long, curved claws

Cute forehead wrinkle

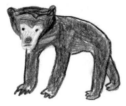

Lustrous black coat

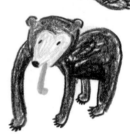

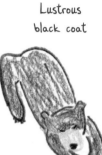

Long tongues perfect for slurping honey from beehives

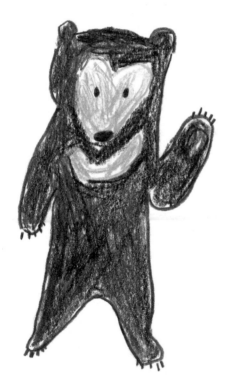

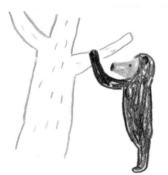

Asian Black Bear

Nicknamed "moon bears," Asian black bears have smooth, black coats with a white crescent of fur on their chests.

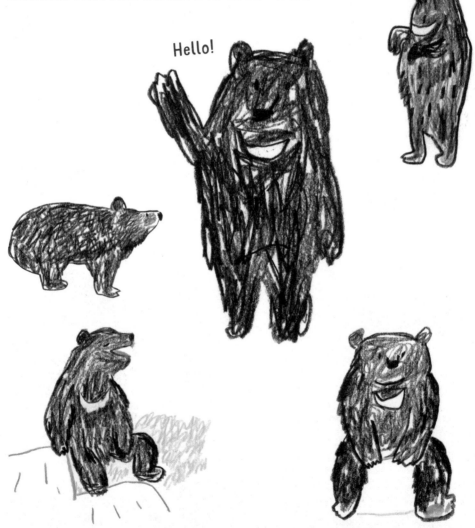

Hello!

GIANT PANDA

Yum yum

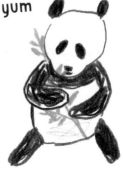

Scientific Name: *Ailuropoda melanoleuca*

Pandas are instantly recognizable by the distinctive black patches around their eyes, ears, arms, and legs.
In Chinese, their name means "big bear cat."

Pandas love to eat bamboo—they consume 20-40 pounds each day!

Pandas love to roll around in the dirt

They're kind of messy!

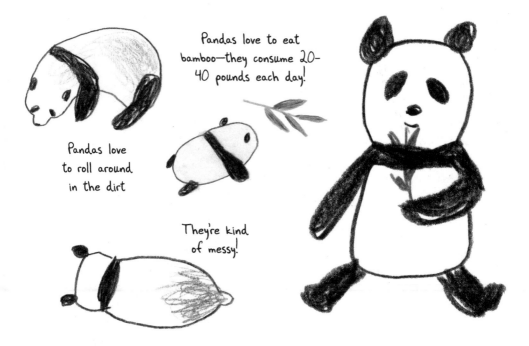

Panda cubs have pink noses

1 Two black circles for ears

2 Two black ovals for eye patches

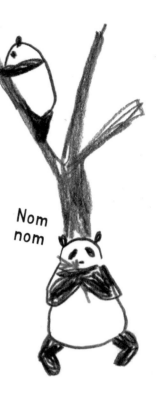

3 Flattened oval for nose

4 Enclose face with circle and add mouth

Don't forget to draw little round eyes inside the black patches!

Nom nom

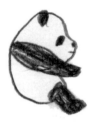

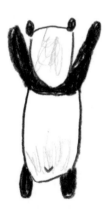

Long tail

Pandas only weigh a few ounces at birth and are born pink and hairless.

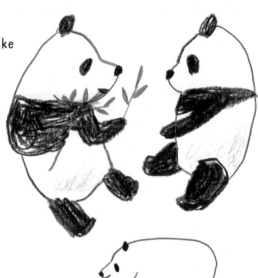

Would you like to share?

1 Make a V, then add a big curve for body and a small curve for head

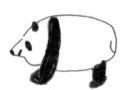

2 Black facial features and ear

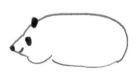

3 Add tummy

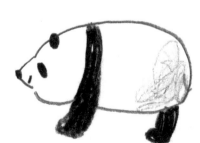

4 Black legs

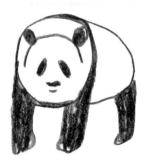

CLOSE UP
Pandas have thick, short white tails.

LESSER PANDA

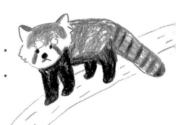

Scientific Name: *Ailurus fulgens*

About the size of a house cat, the lesser panda is actually a relative of the raccoon. Native to the Himalayas, these agile animals sleep in trees for most of the day.

Striped tail

1 Two rounded triangles for ears

2 Connect with a line

3 Use zigzags to outline face

4 Curved line for chin

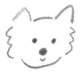 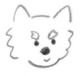 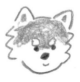 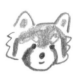

5 Position eyes, nose, and mouth close together at bottom of face

6 Short, thick eyebrows

7 Color top half of face reddish brown

8 Add dark brown lines beneath eyes and on sides of face

Also known as the Red Panda

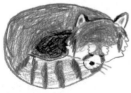

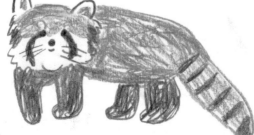

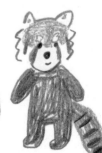

RACCOON

Scientific Name: *Procyon lotor*

Known as the bandits of the animal kingdom, raccoons are notorious food thieves. They even have black rings of fur around their eyes, giving them a masked impression!

1 Rounded triangles that tilt outward for ears

2 Zigzag lines for a furry face

Raccoons are excellent swimmers and climbers.

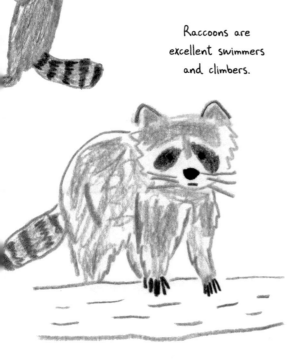

3 V-shaped nose

4 Round nose and eyes—place eyes low on face for a cute look!

5 Dark circles around eyes
tilting downward

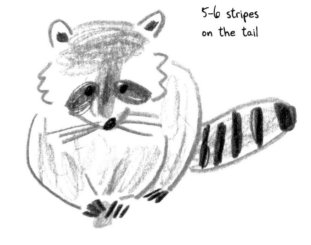

5-6 stripes
on the tail

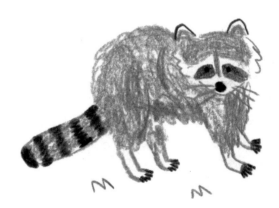

6 T-shape on
forehead and nose

7 Add whiskers

8 Add a straight black
line between eyes

5 fingers

ELEPHANT

Scientific Name: *Loxodonta*

The world's largest land animal, elephants are respected for their high intelligence and excellent memory. Elephants can live to be 70 years old!

1 Connect two arches

2 Ear on each end

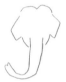

3 Two curved lines form cheeks

4 Long, curved trunk that's thicker at base

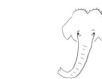

5 Horizontal lines for wrinkles on trunk

6 Eyes at base of trunk and short, little hairs on top of head

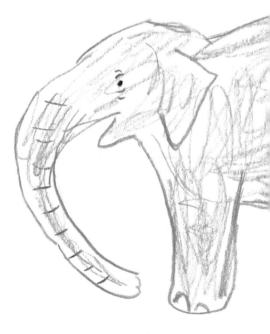

African Elephant

African elephants live on the savanna, which are grasslands. Their noses have two fingerlike projections that they use to grab small items, like leaves and berries.

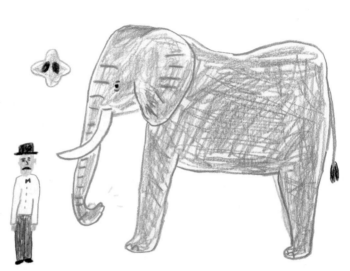

4 toenails 3 toenails

Hairy tail

Asian Elephant

These elephants live in the forests and grasslands of India and southeast Asia. Their noses have only one fingerlike projection at the tip.

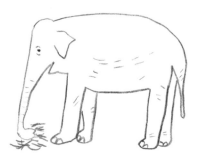

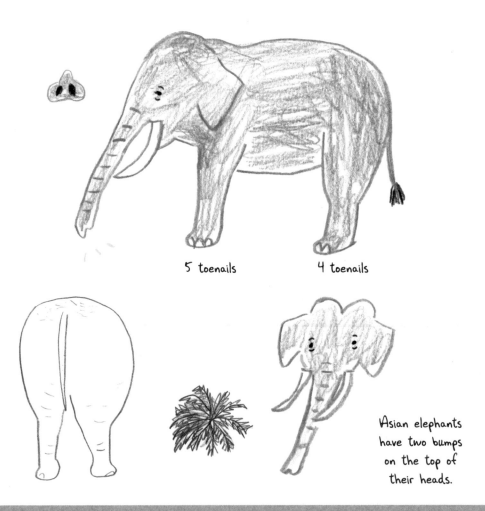

5 toenails 4 toenails

Asian elephants have two bumps on the top of their heads.

African Forest Elephant

These elephants have small, round ears and straighter tusks.

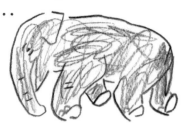

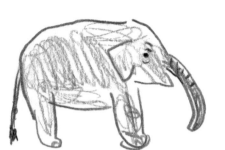

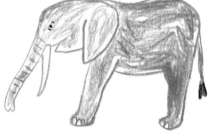

 5 toenails

 4 toenails

THE ELEPHANT DRAWING SONG

1 There is an egg...

2 From that egg, there comes a nose...

3 Then a big rock falls down...

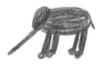

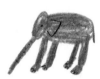

4 From the rock, come two legs...

5 And now two more...

6 And if you'll give him eyes and ears, you'll have an elephant!

PIG

Scientific Name: *Sus scrofa domesticus*

Pigs rank among the smartest of all domestic animals—they're even smarter than dogs! Despite their reputation as dirty animals, pigs are actually quite clean.

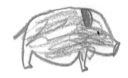

1 Horizontal oval

2 Snout, two legs, and a tail

CLOSE UP
The pig's snout is shorter than the wild boar's.

 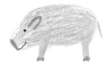

3 Color nose, ear, and hooves dark pink

4 Dark lines on body show movement of hair

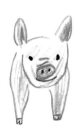

 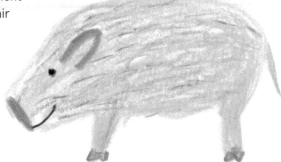

WILD BOAR

Scientific Name: *Sus scrofa*

Wild boars are actually ancestors of the common domestic pig. Just like pigs, wild boars use their strong snouts to forage for food.

1 Horizontal oval with two thick legs and a long snout

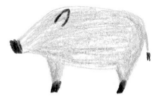

2 Color nose, ear, hooves, and tail dark brown

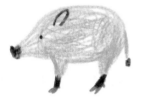

3 Eye positioned between nose and ear

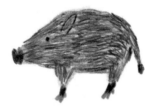

4 Dark zigzags for scruffy hair

CLOSE UP
The hooves are divided into two sections.

HIPPOPOTAMUS

Scientific Name: *Hippopotamus amphibious*

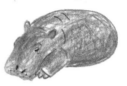

Zzz

Hippos love water—they spend almost all day submerged in rivers and lakes in an effort to keep cool. At night, they leave the water to graze on grass.

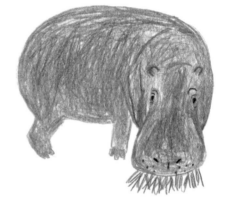

Yum

The nose, eyes, and ears are all in alignment—this allows them to see and breathe while in the water!

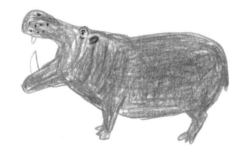

Oxpeckers perch on hippos and eat bugs off their skin.

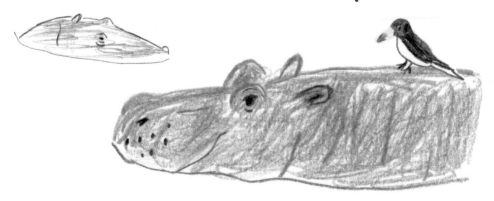

1 Pear-shaped snout and tilted ears

2 Connect with curved lines

3 Two little mountains on upper face

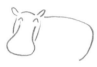

4 Curved line for a big, round body

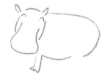

5 Short front leg and a big, saggy tummy

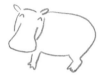

6 Add rear leg

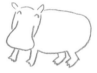

7 Second set of legs

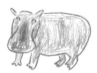

8 Color with gray and pink—shade center of face a bit darker

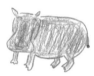

9 Short, flat tail

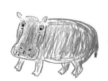

10 Round eyes with wrinkles underneath

CLOSE UP
The nostrils tilt up and out.

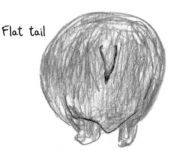

Flat tail

Short legs

CAPYBARA

Scientific Name: *Hydrochoerus hydrochaeris*

The capybara is the largest rodent in the world. They live in groups of 10–40 and spend a lot of time in the water. In fact, they're nicknamed "water pigs."

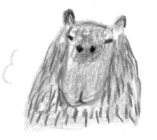

Capybaras have very calm personalities and get along well with other animals.

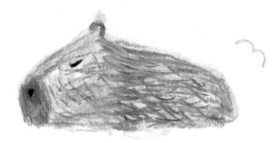

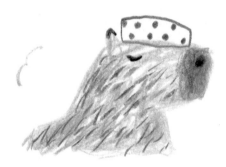

Capybaras who live in zoos love taking warm baths!

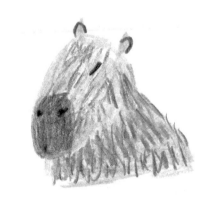

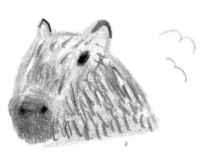

1 Small ears tilted outward

2 Rounded rectangle for face

3 Color face with overlapping lines

4 Dark oval on bottom half of face

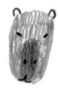

5 Small eyes, nostrils, and a curved line for mouth

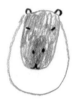

6 Oval "bib" from ear to ear

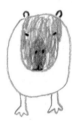

7 Two short legs

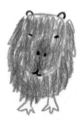

8 Shaggy, scruffy hair

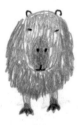

9 Color feet dark brown for a standing capybara

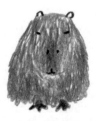

10 Add more hair to body and legs for a sitting capybara

CLOSE UP
Four toes on front feet and three toes on back feet

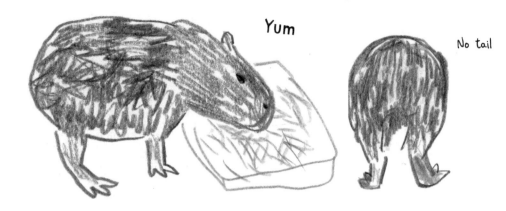

Yum

No tail

Capybaras make different
sounds depending
on the situation:

kyu
kyu

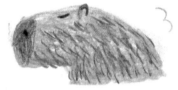

When they're happy, they
make a soft chuckling sound.

goh
goh

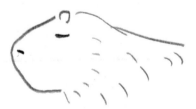

When they're in danger,
they make a shrill
whistling sound.

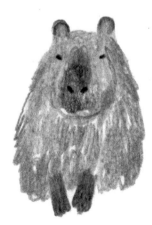

ANTEATER

Scientific Name:
Myrmecophaga tridactyla

Anteaters may not have teeth, but that doesn't stop them from eating up to 30,000 ants and termites a day. They use their long, narrow tongues covered in sticky saliva to break into anthills when they're hungry for a snack.

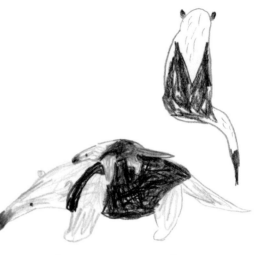

An anteater pup spends the first year of its life hitching a ride on its mother's back.

1 Long face and small ears

2 Color mouth a shade darker than rest of face

3 Add an eye and nose

4 Thick legs

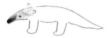

5 Back and long, thick tail

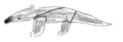

6 Color body brown, then outline middle of back

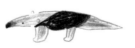

7 Fill outlined area with black or dark brown

CLOSE UP
Their claws curl up into their feet when they walk in order to keep them sharp for digging.

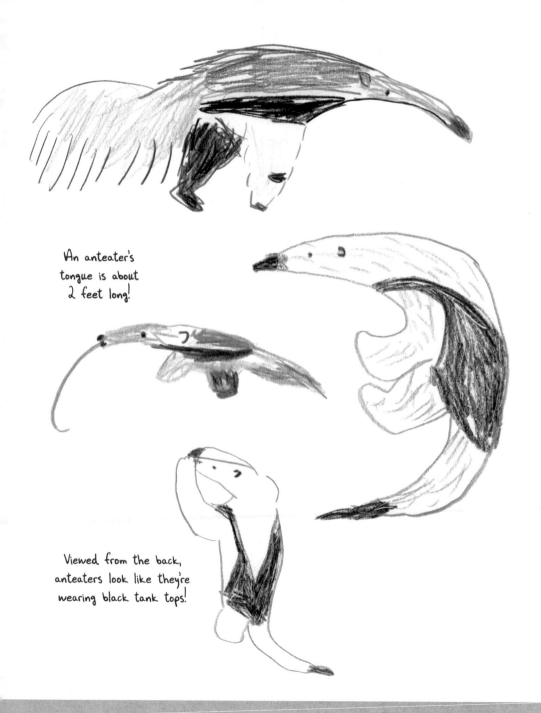

An anteater's tongue is about 2 feet long!

Viewed from the back, anteaters look like they're wearing black tank tops!

KOALA

Scientific Name: *Phascolarctos cinereus*

Koalas spend almost all of their time in trees. They sleep for up to 18 hours a day and spend the rest of their time eating eucalyptus leaves.

Koalas are picky eaters—they only eat eucalyptus leaves.

Koalas in southern Australia are larger and have thicker fur.

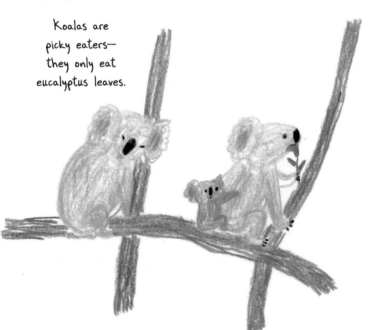

Just like kangaroos, female koalas carry their babies around in a pouch.

Front paw has two thumbs for gripping branches.

Back paw has two fingers fused together to form a grooming claw.

They conserve energy by sleeping most of the day.

 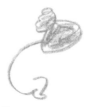

1 Shell-shaped head and a flower-shaped ear

2 Big curve for body

3 Add back leg

4 Add front leg

5 Color body

6 Add eye, nose, mouth, and claws

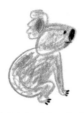 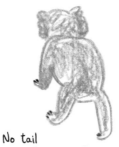 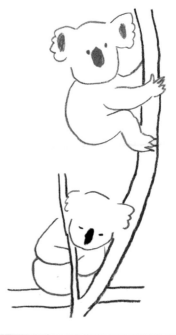

7 Add a bit of pink to ear and mouth

No tail

Albino koalas are extremely rare—they have white fur with pink eyes and noses.

PATAGONIAN MARA

Scientific Name: *Dolichotis patagonum*

Patagonian maras may look and move like rabbits, but they're actually rodents. They can leap 6 ft (1.8 m) in the air when startled.

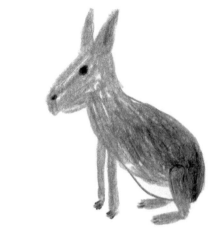

Darker hair at the hips

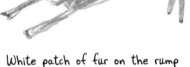

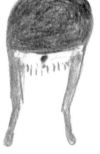

White patch of fur on the rump and a short, hairless tail

Long ears and big eyes

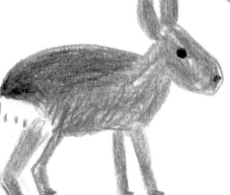

Black whiskers

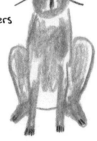

White tummy

1 Bunny ear and face

2 Flat back and round rump

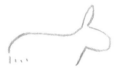

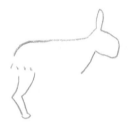

3 Row of short lines beneath rump

4 Two V-shapes for back leg

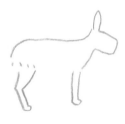

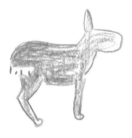

5 Straight front leg

6 Color body with overlapping lines

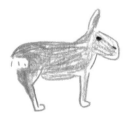

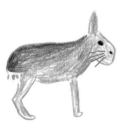

7 Big eye and a nostril

8 Gradated shades of brown and black

CAMEL

Scientific Name: *Camelus*

Ever wonder what's inside a camel's humps? The humps store fat, allowing the animal to survive months without eating.

Bactrian camels have two humps.

Dromedary camels have only one hump.

They can close their nostrils!

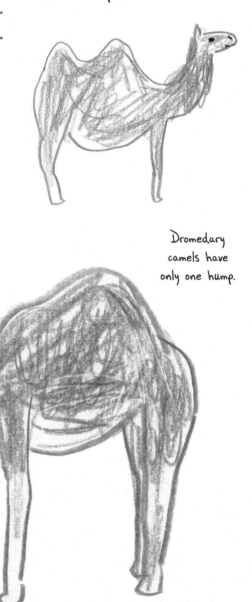

Long, thick eyelashes

1 Grain of rice for ear

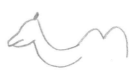

2 Pointed face

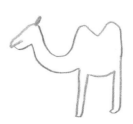

3 Add chin

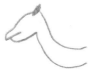

4 Long, curved neck

5 M-shaped humps

6 Long, skinny legs

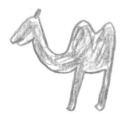

7 Color body

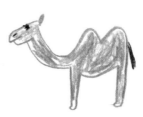

8 Add an eye, nostril, and tail

HYENA

Scientific Name: *Hyaenidae*

Even though they're skilled hunters, hyenas are famous scavengers and often eat the leftovers of other predators. Hyena clans are matriarchal, which means that females dominate the group.

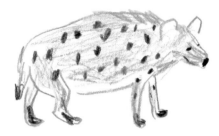

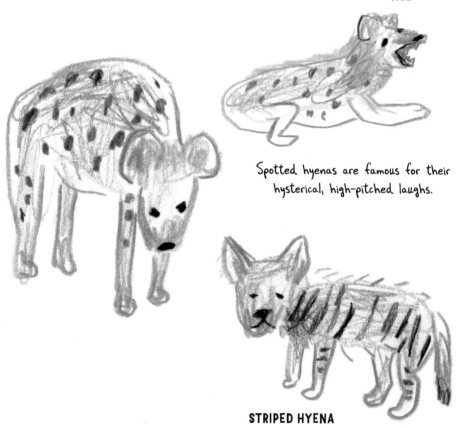

SPOTTED HYENA

HEE
HEE
HEE

Spotted hyenas are famous for their hysterical, high-pitched laughs.

STRIPED HYENA

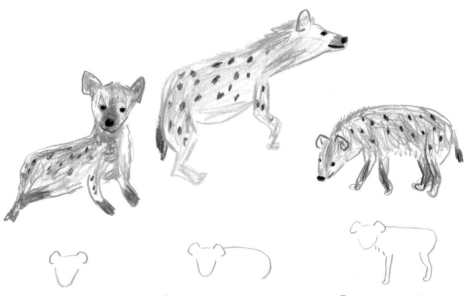

1 Big ears and a pointy face

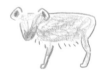

2 Gentle curve for body

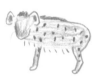

3 Back legs thicker than front

4 Short lines for hairy tummy

5 Color gray or brown, making ears and nose darker than rest of body

6 Add spots or stripes and a mane on head and back

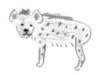

7 Add round eyes, a nose and a mouth

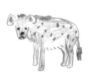

8 Shorter second set of legs and a tail

CLOSE UP
The tail should be short and have a black tip.

WOLF

Scientific Name: *Canis lupus*

Wolves live in groups of 2–12 members called packs. They roam large distances (up to 12 miles [19 km] a day) hunting for prey.

Oh Grandmother, what big ears you have!

White fur extending from chin to tummy

Aroo!

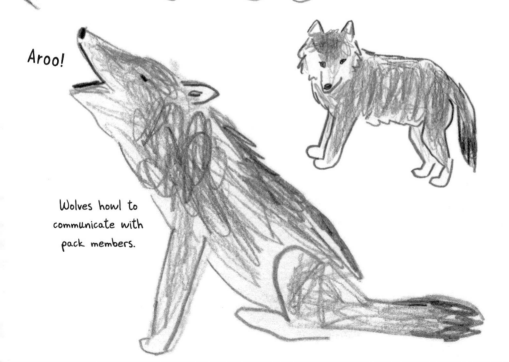

Wolves howl to communicate with pack members.

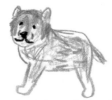

Use short lines to create fluffy fur on the wolf pup's head and body.

1 Pointed ears and wavy fur on face

2 V-shaped muzzle and short, overlapping lines for back and tail

CLOSE UP
Use a few short lines to depict a thick mane.

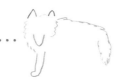

3 Front leg

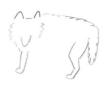

4 Thicker back leg

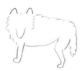

5 Curved line for tummy

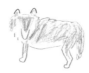

6 Color body gray or brown, but leave cheeks and tummy white

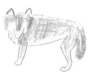

7 Add thick, fluffy fur to tail

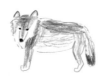

8 Add eyes and nose, then color tip of tail a darker shade than rest of body

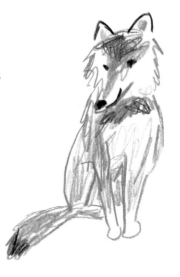

KANGAROO

Scientific Name: *Macropus*

Kangaroos have large, powerful feet which allow them to leap up to 30 ft (9 m) in a single bound! Their long tails also provide balance while jumping.

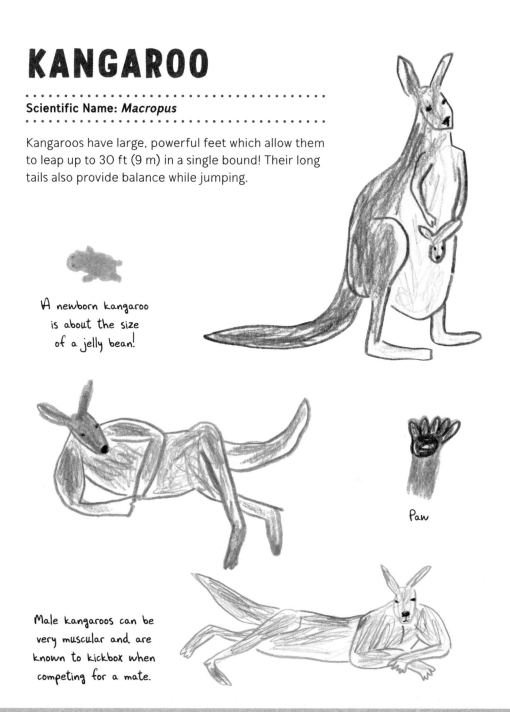

A newborn kangaroo is about the size of a jelly bean!

Paw

Male kangaroos can be very muscular and are known to kickbox when competing for a mate.

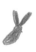 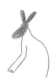 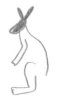 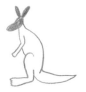

1 Bean–shaped face and long bunny ears

2 Bent arm and gentle curve for back

3 Big, strong foot

4 Long, thick tail that touches ground

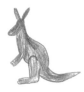 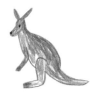

5 Color brown, using a slightly darker shade along back

6 Add eye, nose, and claws

The joey jumps into the pouch head first.

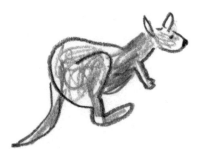

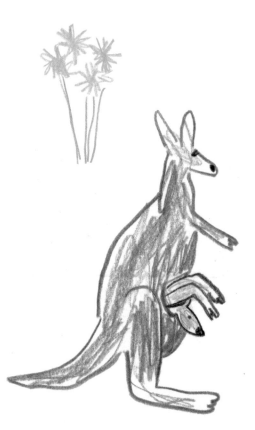

SIMILAR ANIMALS

Wallaroo

A wallaroo is smaller than a kangaroo but larger than a wallaby.

The major difference between a kangaroo, wallaroo, and wallaby: size.

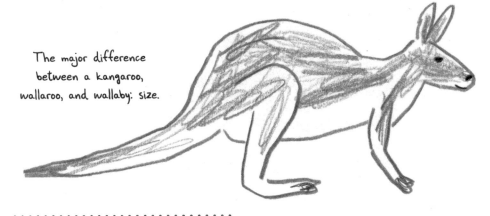

Wallaby

The wallaby is the smallest member of the kangaroo family.

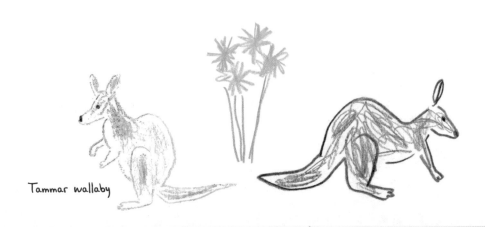

Tammar wallaby

MONKEY

Scientific Name: *Primates*

There are nearly 300 species of
monkeys, many of which live in the
world's tropical rainforests.

Characteristic
pink face, ears,
and butt

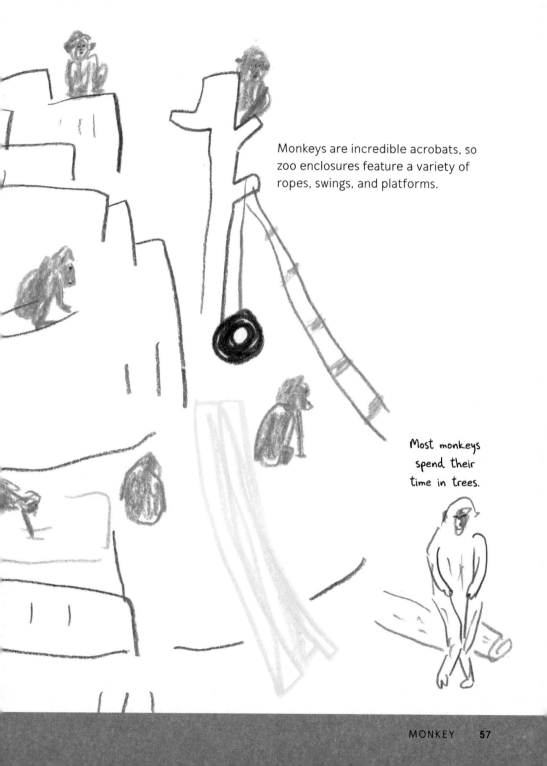

Monkeys are incredible acrobats, so zoo enclosures feature a variety of ropes, swings, and platforms.

Most monkeys spend their time in trees.

JAPANESE MACAQUE

Scientific Name: *Macaca fuscata*

Also called snow monkeys, Japanese macaques live in mountainous northern Japan. Every year, swarms of these monkeys descend upon a specific park to bathe in the hot springs.

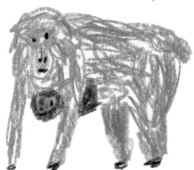

Baby monkeys cling to their mothers for transport

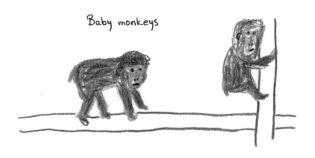

They huddle together to keep warm

Baby monkeys

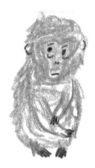

1 Pink, mushroom-shaped face

2 Two round eyes, two small nostrils, and a horizontal line for mouth

3 Scribble a circle of hair around face

4 Add the ears

CLOSE UP
Don't forget the ears! Position them on the same level as the eyes.

5 Short lines for a hairy chest, and a thick front leg

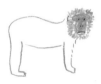

6 Curvy back with a rump that sticks up, then add back leg and tummy

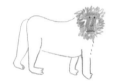

7 Second set of legs is a bit shorter

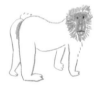

8 Pink butt

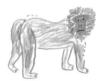

9 Color body light brown or gray

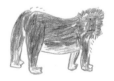

10 Leave tummy white

SQUIRREL MONKEY

Scientific Name: *Saimiri*

Squirrel monkeys live in large groups that can contain up to 500 members. Unlike other monkeys, they use their long tails for balance instead of climbing.

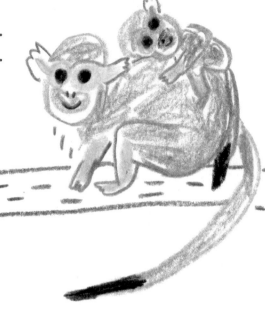

1 Eyeglass shape

2 Semicircle on top for forehead

3 Outline ears with zigzags, then draw a semicircle for chin

4 Gray heart for mouth area

5 Big, round eyes, nostrils, and a smiling mouth

CLOSE UP
Leave the ears white.

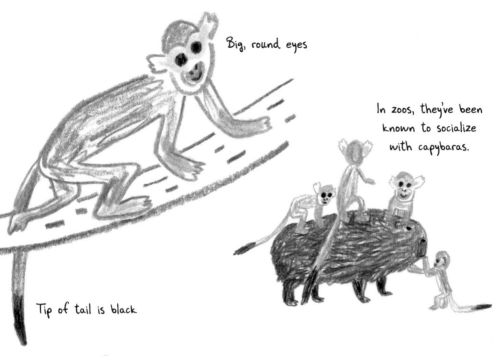

Big, round eyes

In zoos, they've been known to socialize with capybaras.

Tip of tail is black

6 Short lines for a hairy chest and a short front leg

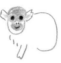

7 Nice round curve for body

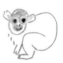

8 Back leg should be thicker and longer than front leg

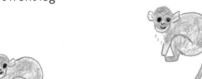

9 Color body yellow and gray

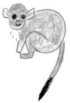

10 Long tail that hangs down

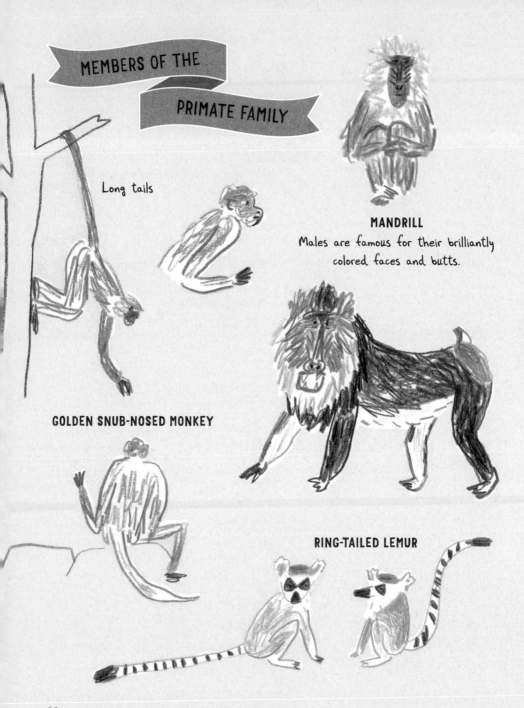

MEMBERS OF THE PRIMATE FAMILY

Long tails

MANDRILL
Males are famous for their brilliantly colored faces and butts.

GOLDEN SNUB-NOSED MONKEY

RING-TAILED LEMUR

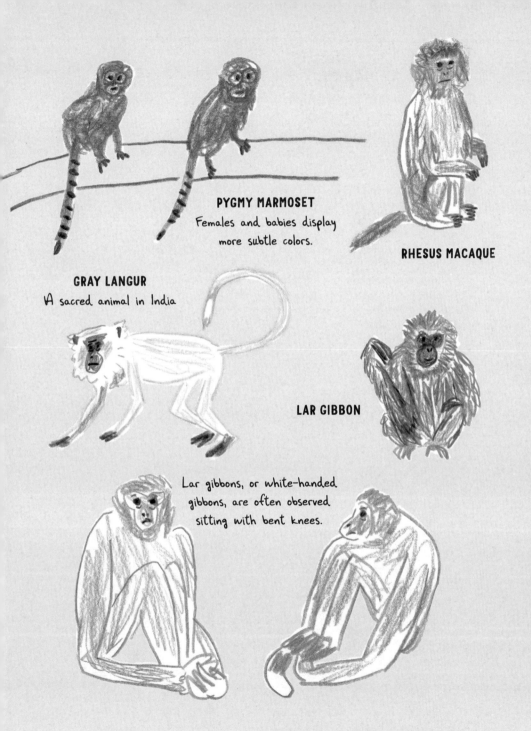

PYGMY MARMOSET
Females and babies display more subtle colors.

RHESUS MACAQUE

GRAY LANGUR
A sacred animal in India

LAR GIBBON

Lar gibbons, or white-handed gibbons, are often observed sitting with bent knees.

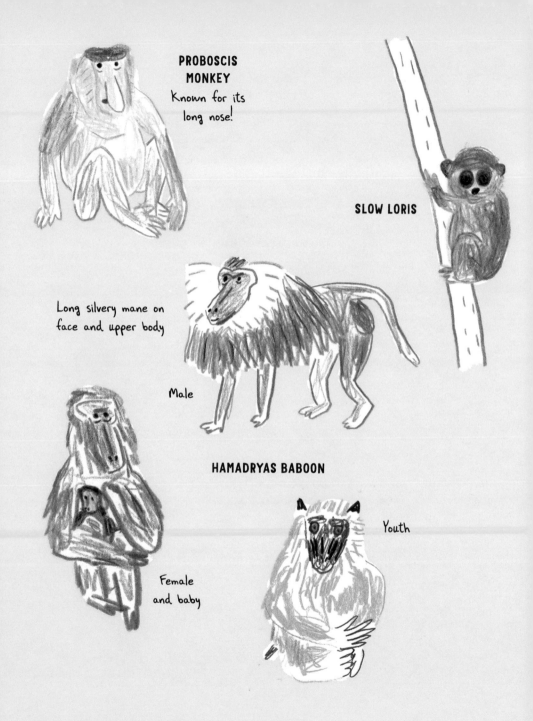

PROBOSCIS MONKEY
Known for its long nose!

SLOW LORIS

Long silvery mane on face and upper body

Male

HAMADRYAS BABOON

Youth

Female and baby

GORILLA

Scientific Name: *Gorilla gorilla*

Considered to be gentle giants, gorillas live in family groups of 5–30 members and spend most of their time eating plants.

"Silverback" gorillas are the leaders of the family groups.

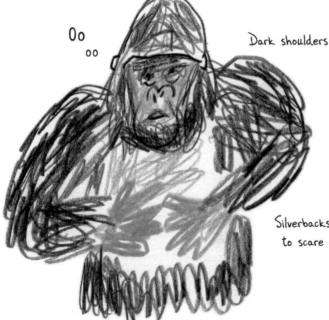

Oo
oo

Dark shoulders

Silverbacks beat their chests to scare challengers away.

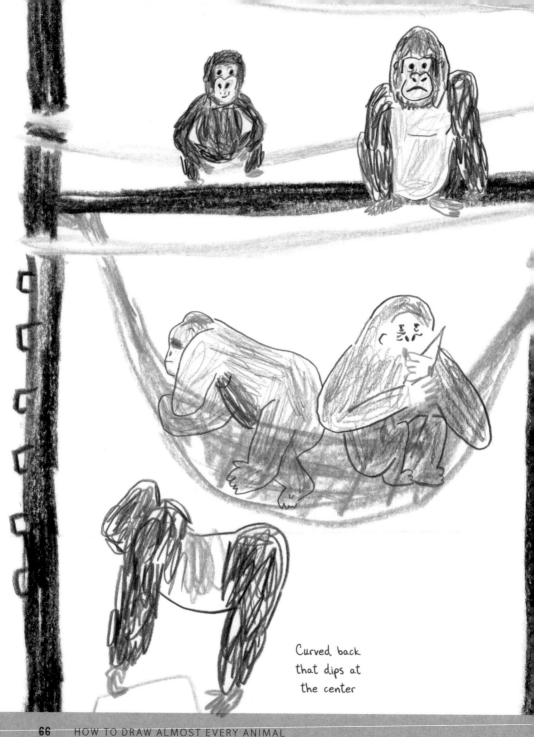

Curved back
that dips at
the center

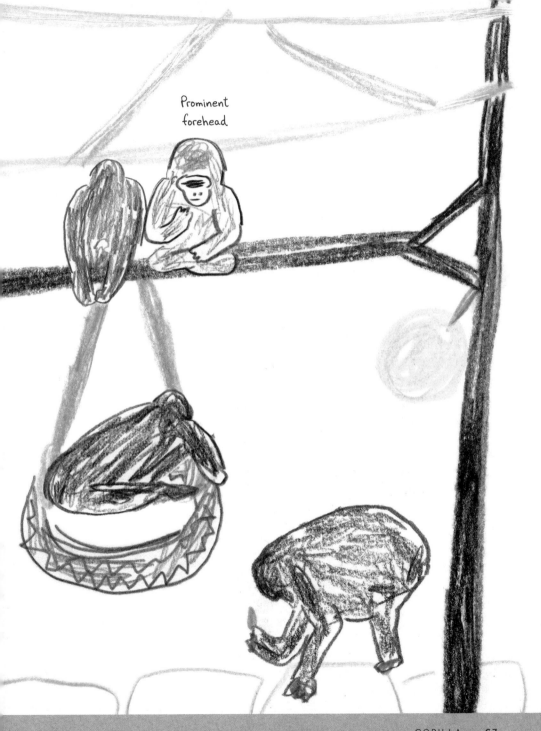

Prominent forehead

CHIMPANZEE

Scientific Name: Pan troglodytes

Chimpanzees are extremely intelligent animals—they communicate with each other using expressions, gestures, and sounds, and can even be taught basic human sign language!

Chimps are also knuckle-walkers

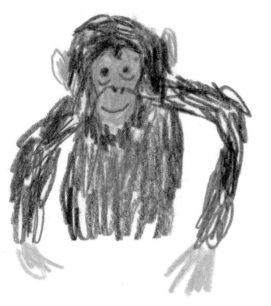

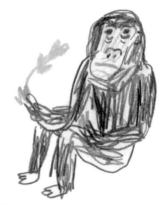

This is a bonobo—another species of ape similar to the chimpanzee

1 Teardrop with a heart positioned above

2 Add eyes, nostrils, and mouth

CLOSE UP Draw wrinkles above and below the eyes.

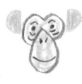

3 Big ears on same level as eyes

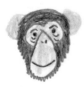

4 Enclose face and color with short black lines

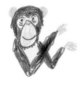

5 Long arms with beige hands

6 Oval body 1.5–2 times larger than head

7 Legs are slightly shorter than arms

ORANGUTAN

Scientific Name: *Pongo*

Male orangutans have huge arm spans, stretching 7 ft (2 m) from fingertip to fingertip. These long arms allow them to swing from branch to branch with ease.

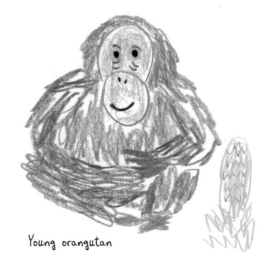

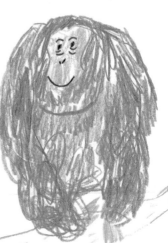

Young orangutan

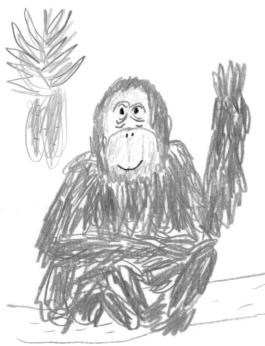

They spend 90% of their time in trees.

 1 Small circle

 2 Two little beige circles with a big overlapping circle below

 3 Add eyes, nostrils, and mouth

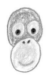 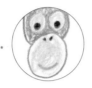 **4** Color top circle dark, but leave area around eyes beige

CLOSE UP
Baby orangutans have light faces that will change to dark brown or black as they grow up.

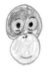 **5** Wrinkles above and below eyes

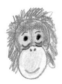 **6** Messy red hair around face

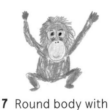 **7** Round body with long arms and legs

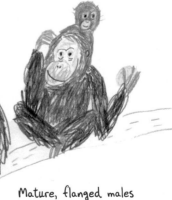

Mature, flanged males have big cheeks.

DEER

Scientific Name: *Cervidae*

Male deer, called bucks, grow a new set of antlers every year. They use their antlers to attract mates and compete with other males.

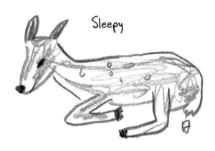

Sleepy

Stinky

Antlers are made of bone.

White tail

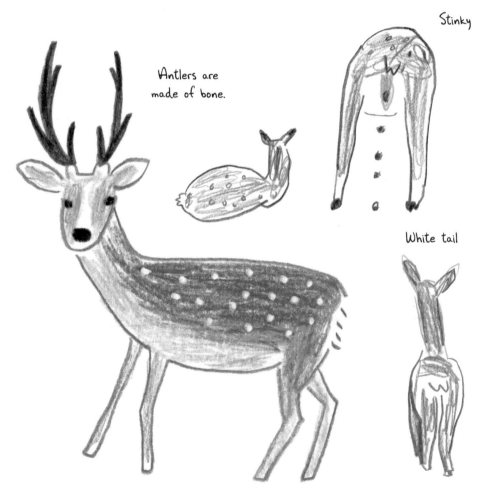

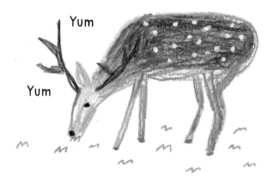

Yum

Yum

A baby deer is called a fawn.

1 Long ears and a skinny face

2 Two bumps in between ears

3 Smoothly curved back with short lines on rump

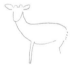

4 Long, graceful neck and a skinny front leg

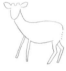

5 Add remaining legs— back legs should be thicker than front legs

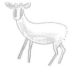

6 Color legs and face brown

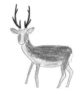

7 Draw tree branch-shaped antlers, then shade sides of face and back darker brown

CLOSE UP
Each antler should have 3-5 branches.

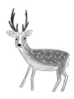

8 Add eyes and nose, then cover body with white dots

REINDEER

Scientific Name: *Rangifer tarandus*

Both male and female reindeer grow antlers. In fact, reindeer have the largest antler of all deer species.

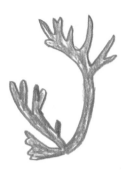

Check out those antlers!

Merry Christmas!

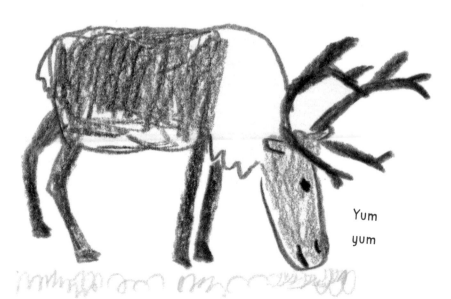

Yum yum

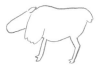 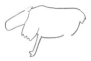

1 Rectangular face with a leaflike ear

2 Wavy fur on chest

3 Back with a small bump at shoulder and a short tail

4 Front leg below chest

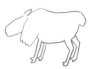 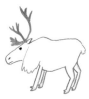 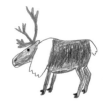

5 Thicker back leg

6 Shorter second set of legs

7 Add large antlers, eyes, nose, and mouth

8 Color face and body brown, leaving fur on chest, neck, and tail white

It looks like he's wearing a white scarf around his neck!

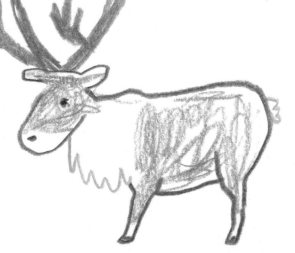

SHEEP

Scientific Name: *Ovis aries*

Sheep were one of the first animals domesticated by humans. They have thick fleeces that are used to produce wool.

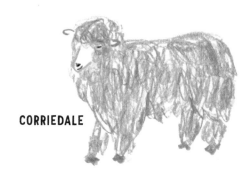

CORRIEDALE

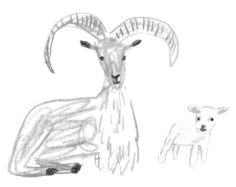

BARBARY

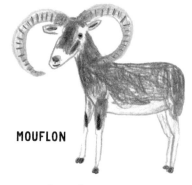

MOUFLON

One of the ancestors of domesticated sheep

Baaaaa

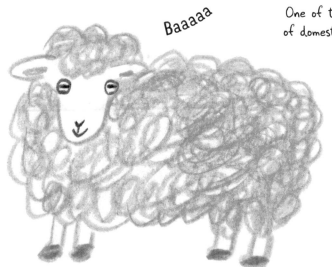

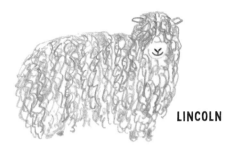

LINCOLN

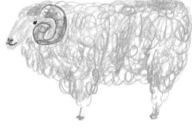

MERINO

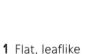

1 Flat, leaflike ears and a U-shaped face

2 Add a wavy line between ears

3 Outline body and rear leg using wavy lines

4 Add second rear leg using wavy lines

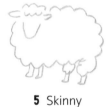

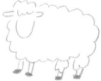

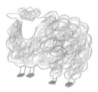

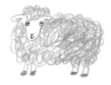

5 Skinny front legs

6 Add hooves

7 Use scribbly lines to color body, but leave face white

8 Add eyes, nose, and mouth

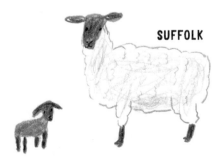

SUFFOLK

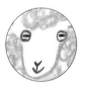

CLOSE UP

To draw classic sheep eyes, make a circle, then add a horizontal line. Round black eyes also work well!

GOAT

Scientific Name: *Capra aegagrus hircus*

After the dog, goats are the oldest domesticated animals. Both male and female goats can have horns and beards.

Naaaa

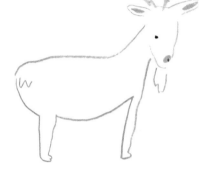

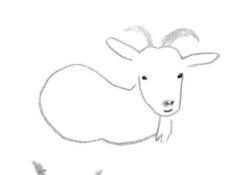

Goats have a reputation for eating anything, including paper!

Tail points up

Saggy tummy

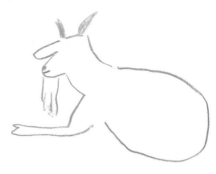

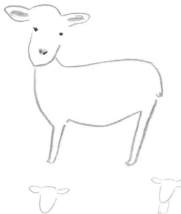

 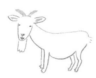 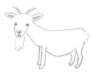

1 Flat, leaflike ears and a U-shaped face

2 Zigzag beard extending from chin

3 Color nose and inner ears pink

4 Draw nose, mouth, and small eyes positioned toward sides of face

5 Short, curved horns between ears

6 Round body with a saggy tummy

7 Outline eyes with a circle

CLOSE UP
A goat's eye is similar to a sheep's, but their pupils are rectangular.

CLOSE UP
Use a few short lines to depict the hair on the rump.

ALPACA

Scientific Name: *Vicugna pacos*

Alpacas are domesticated animals native to South America. Their soft, luxurious fleece is used to make sweaters, blankets, and other knitted items.

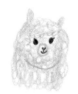

Watch out! Alpacas are known to spit.

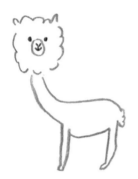

They look goofy after their fleece is shorn!

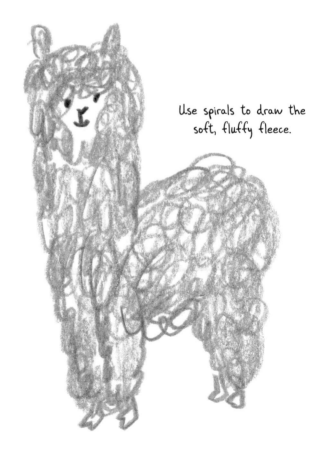

Use spirals to draw the soft, fluffy fleece.

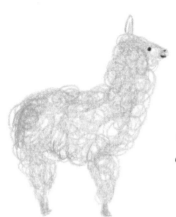

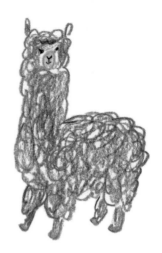

Alpaca fleece is one of the most expensive fibers around.

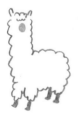

1 Two ears connected with a wavy line

2 Two wavy vertical lines extending from ears—one short, one long

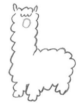

3 Rectangular body with short legs

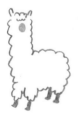

4 Oval face and hooves

5 Add facial features and cover body with spirals

CLOSE UP
Draw a line extending from the eye to capture the alpaca's long lashes.

LLAMA

Scientific Name: *Lama glama*

Llamas are also domesticated animals native to South America. They're much larger than alpacas and are often used as pack animals.

Big eyes and long lashes

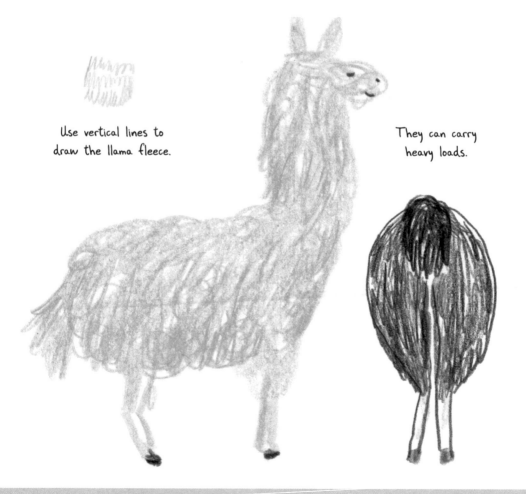

Use vertical lines to draw the llama fleece.

They can carry heavy loads.

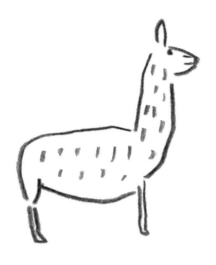

1 Triangular face with banana-shaped ears

CLOSE UP
One way to tell llamas and alpacas apart: the ears. Llamas have long, curved ears.

2 Long, thick neck

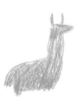

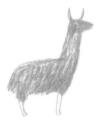

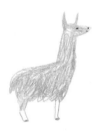

3 Color body with vertical lines

4 Skinny legs

5 Add eye, nose, mouth, and hooves

COW

Scientific Name: *Bos taurus*

Cattle, commonly referred to as cows, are raised as livestock for meat and dairy, as well as draft animals to pull plows and carts.

Moo

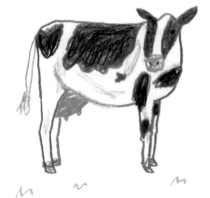

WAGYU

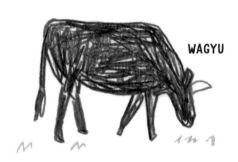

1 Two flat, leaflike ears connected with a gently curved line

2 Long face with a different color for nose

3 Eyes on side of face and nostrils on nose

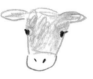

4 Color face, except for nose

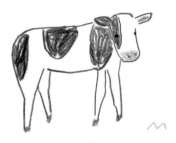

HOLSTEIN

JERSEY

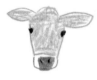

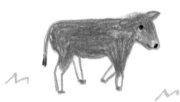

5 Color nose, leaving edges white

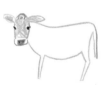

6 Draw body with a gently curved back

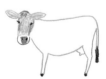

7 Color tip of tail and hooves black

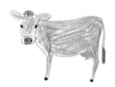

8 Color body—for a female,
draw pink udders

MEMBERS OF THE COW FAMILY

ARABIAN ORYX
Long, straight horns

WILD YAK

ZEBRA DUIKER

TEXAS TORNADO BULL

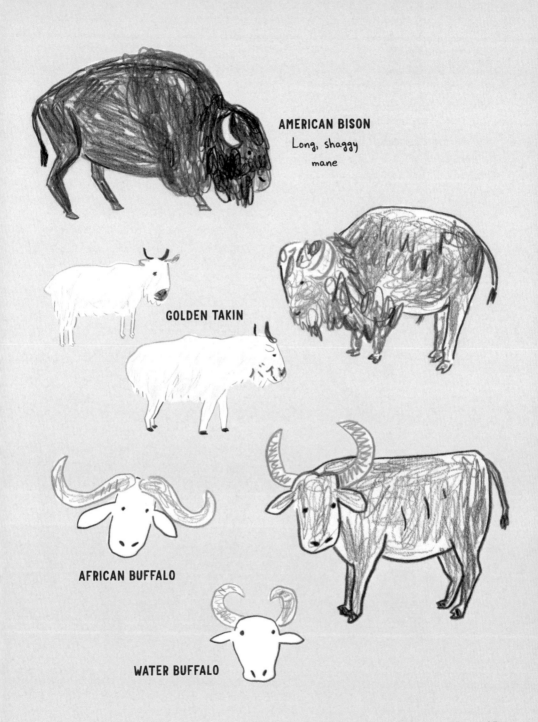

AMERICAN BISON
Long, shaggy mane

GOLDEN TAKIN

AFRICAN BUFFALO

WATER BUFFALO

HORSE

Scientific Name: *Equus ferus caballus*

The relationship between horses and humans dates back thousands of years. Historically, these majestic animals were essential to human transportation.

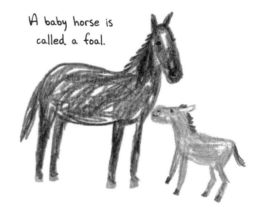

A baby horse is called a foal.

THOROUGHBRED

1 Two narrow ears pointing up

2 Long face shaped like a grain of rice

3 Color face and ears brown

4 Black mane on top of head

5 Slitlike eyes on side of face and big nostrils on nose

CLOSE UP
The are many different varieties of horse manes—some are even braided in fancy styles!

6 White patch extending from forehead to nose

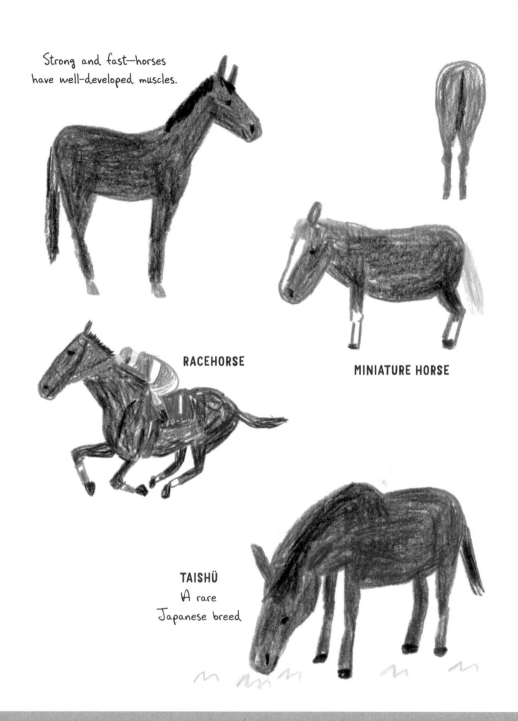

Strong and fast—horses have well-developed muscles.

RACEHORSE

MINIATURE HORSE

TAISHÜ
A rare
Japanese breed

STOAT

Scientific Name: Mustela erminea

A stoat is a type of weasel. The stoat's coat is brown or gray during the summer, then turns completely white (except for the tip of the tail) during the winter. This white fur, known as ermine, is a symbol of royalty.

Winter coat

Long nose

They're good swimmers.

Summer coat

White tummy

JAPANESE MARTEN

WEASEL

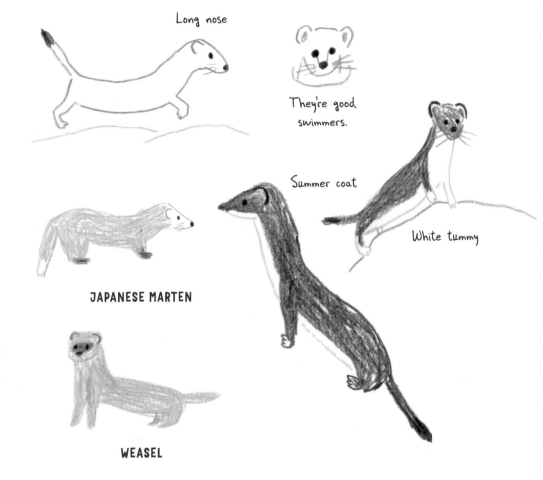

1 Rounded ears connected with a curved line

2 Wide U for face

3 Big, round eyes, a flat nose, and a upside down V mouth

4 Curved front leg below face

5 Long, gentle curve for back

CLOSE UP
Big eyes give the stoat a cute look.

6 Flat tummy and bent hind leg

7 Long, skinny tail

8 Add whiskers and color tip of tail black

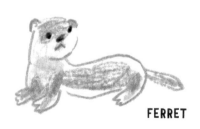

FERRET

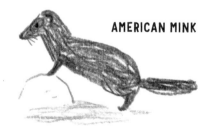

AMERICAN MINK

DONKEY

Scientific Name: *Equus asinus*

Although they have a reputation for stubbornness, donkeys are quiet, dependable pack animals. They are hard workers and are known to protect other farm animals.

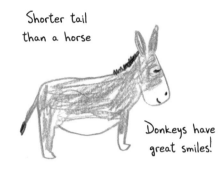

Shorter tail than a horse

Donkeys have great smiles!

Long, floppy ears

White muzzle and tummy

The donkey is part of a famous statue honoring the fairytale "The Town Musicians of Bremen"

1 Long ear sticking straight up

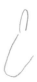

2 Long, rectangular face with rounded corners

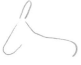

3 Curved line for back and rump

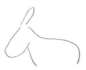

4 Puffy chest

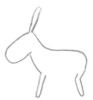

5 Short legs

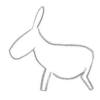

6 Big, saggy tummy

7 Color brown or gray, but leave muzzle and tummy white

8 Black facial features, mane, tail, and hooves

GIRAFFE

Scientific Name:
Giraffa camelopardalis

At 15–20 ft (4–6 m), giraffes are the world's tallest mammals. Believe it or not, giraffes sleep only 30 minutes a day!

ROTHSCHILD'S GIRAFFE

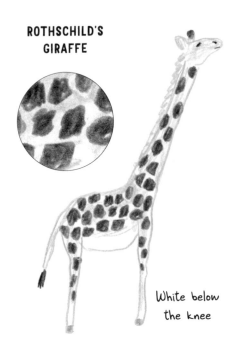

White below the knee

SOMALI GIRAFFE

MASAI GIRAFFE

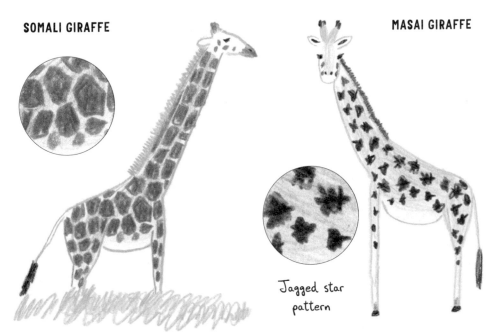

Jagged star pattern

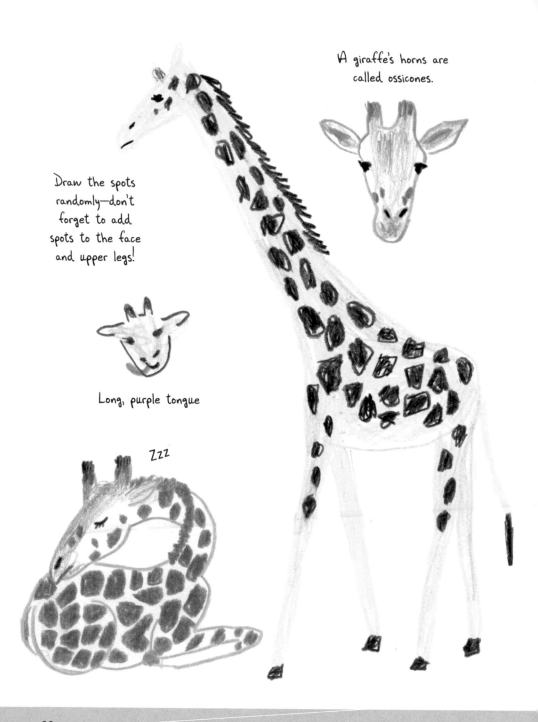

A giraffe's horns are called ossicones.

Draw the spots randomly—don't forget to add spots to the face and upper legs!

Long, purple tongue

Zzz

1 Leaf-shaped ears and a long, thin face with a yellow Y-shape

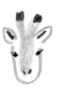

2 Color tips of horns in a dark shade, then add eyes and nostrils

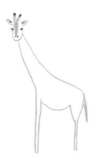

3 Extremely long neck, thin legs, and a round tummy

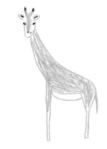

4 Leave tummy white

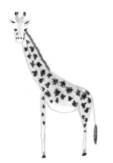

5 Add spots and mane

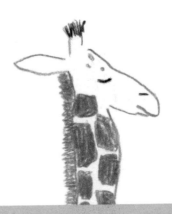

ZEBRA

Scientific Name: *Equus quagga*

A zebra's stripes are as unique as a human's fingerprints—no two are exactly alike—although each species has its own general pattern.

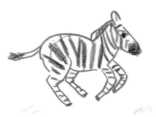

Zebras are actually born with brown stripes!

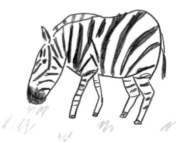

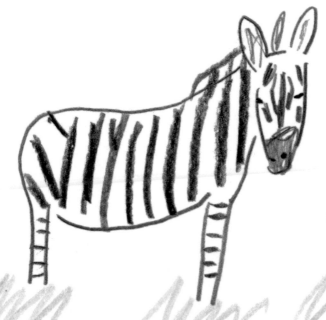

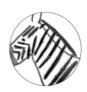

CLOSE UP
Zebras even have striped manes! Draw continuous stripes extending from the neck to the mane.

1 Rectangular face and an ear standing straight up

2 Curved back and a round rump

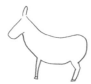

3 Curved chest and round tummy

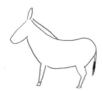

4 Add mane and tail—color tip of tail black

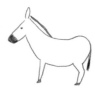

5 Color nose and edge of mane black, then add an eye

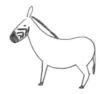

6 V-shaped stripes on face

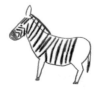

7 Slanted lines for stripes on neck and body and a V-shaped stripe where front leg meets body

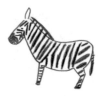

8 Horizontal stripes on legs, rump, and tail

Mountain Zebra

These zebras are good climbers!

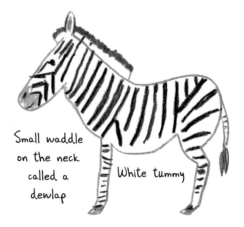

Small waddle
on the neck
called a
dewlap

White tummy

Ladder-like
stripe pattern
at the waist

Plains Zebra

This the most common zebra species.

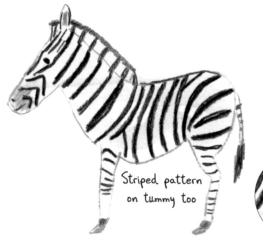

Striped pattern
on tummy too

Grevy's Zebra

This is the largest zebra species.
It's named after a former
French president.

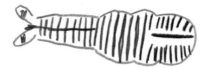

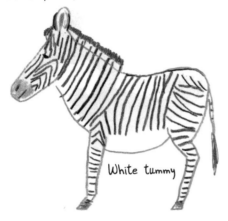

White tummy

Thin stripes

Chapman's Zebra

This subspecies of the plains zebra
has "shadow stripes" between its
main stripes.

Chapman's
zebra rump

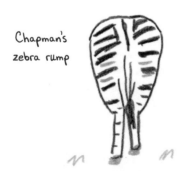

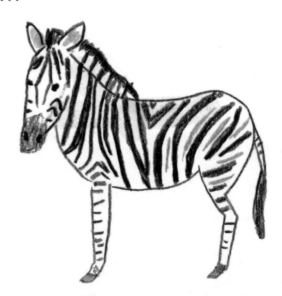

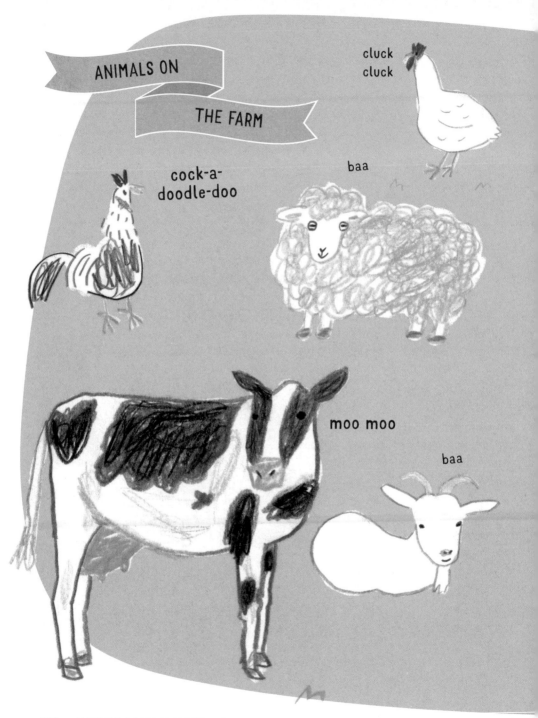

ANIMALS ON

THE FARM

cluck
cluck

cock-a-
doodle-doo

baa

moo moo

baa

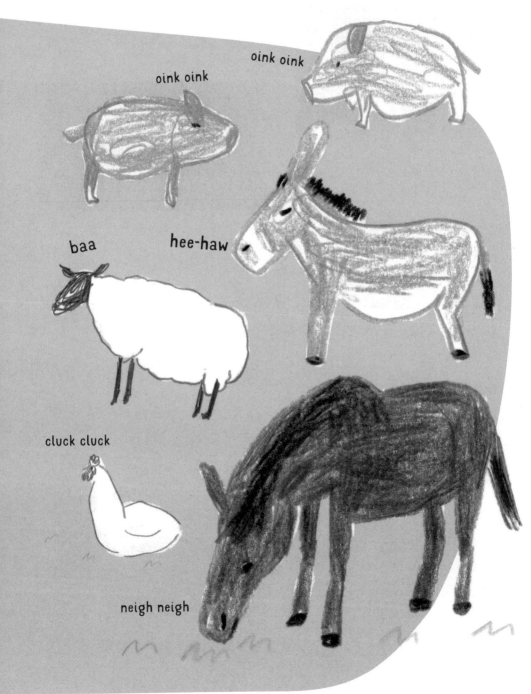

oink oink

oink oink

baa hee-haw

cluck cluck

neigh neigh

MALAYAN TAPIR

Scientific Name: *Tapirus indicus*

Tapirs are primitive animals that have remained unchanged for millions of years. These unusual creatures have a combined nose and upper lip that forms a snout similar to an elephant's trunk. It can even be used as a snorkel when the tapir is underwater.

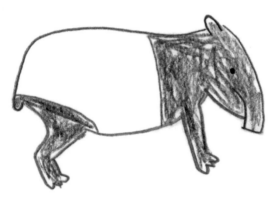

Bird's-eye view

Unique black and white pattern
serves as camouflage

SOUTH AMERICAN TAPIR

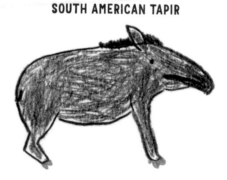

Soft, flexible
snout

1 Unique snout curves downward

2 Chin extends from middle of snout

3 Gentle curve for back and a short tail

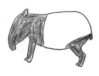

4 Short legs with three toes each

5 Connect back leg and tail with a curve

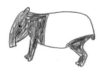

6 Divide body into three sections

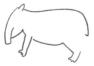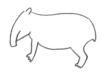

7 Color body black, leaving middle section white

CLOSE UP
Color the tail black too.

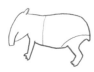

8 Add a small round eye

Round rump

The tapir resembles baku, a creature of Japanese folklore called upon to "eat" nightmares.

OTTER

Scientific Name: *Lutrinae*

Otters are designed for life in the water! Their webbed feet make them excellent swimmers, while their thick fur coats keep them warm in near-freezing water temperatures.

Cute little faces

They usually walk on all fours, but you'll occasionally catch them standing up.

White tummy

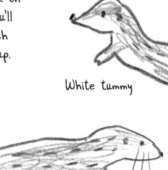

They're fast swimmers

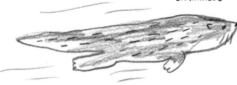

CLOSE UP
Don't forget the whiskers!

1 Two tiny ears connected with a curved line

2 Short arm with five fingers

3 Long body with a rounded tummy and a short arm

4 Short legs

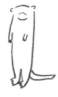

5 Triangular nose, round chin, and long tail

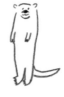

6 Add eyes, nose, and mouth

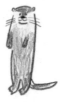

7 Color forehead and body brown, leaving neck and face white

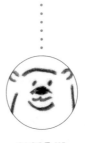

CLOSE UP
Draw a horizontal black oval for the nose, positioned under the triangle.

SQUIRREL

Scientific Name: *Sciuridae*

Most squirrels don't hibernate, so they store nuts and acorns for the winter months. If a squirrel forgets where he buried a nut, it will grow into a tree!

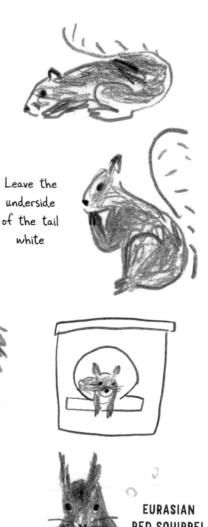

Leave the underside of the tail white

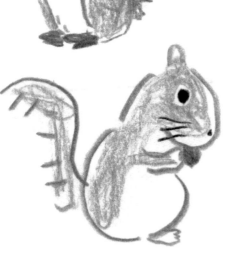

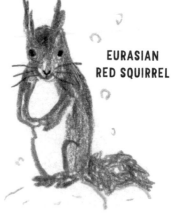

EURASIAN RED SQUIRREL

There are over 200 species of squirrels! Check out the next page for some more squirrels.

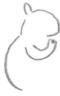

1 Oblong ear

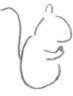

2 Round, protruding face

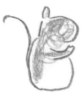

3 Nice round curve for back

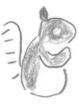

4 Big, sweeping curve for tail

5 Color face, arm, and back brown

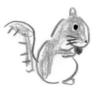

6 Horizontal lines across tail

7 Color in most of tail, leaving underside white

8 Add eyes, nose, whiskers, and feet . . . don't forget an acorn!

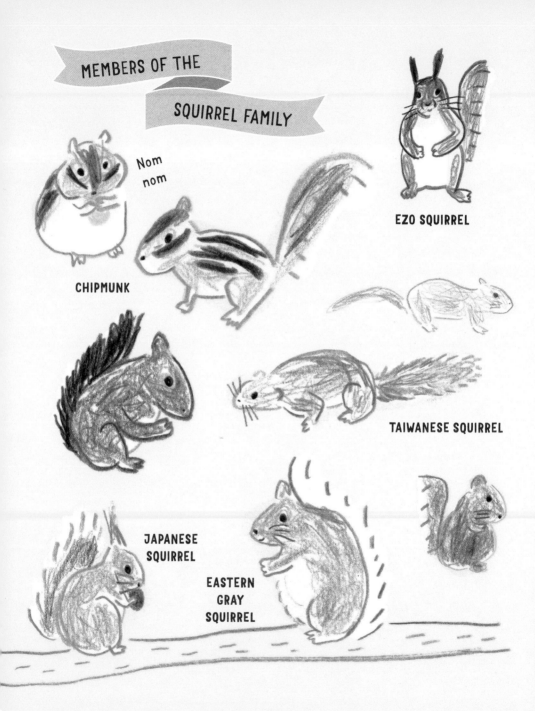

MEMBERS OF THE

SQUIRREL FAMILY

Nom nom

CHIPMUNK

EZO SQUIRREL

TAIWANESE SQUIRREL

JAPANESE SQUIRREL

EASTERN GRAY SQUIRREL

JAPANESE GIANT FLYING SQUIRREL

Scientific Name: *Petaurista leucogenys*

These large squirrels have a special skin membrane between their arms, legs, and tail which allows them to glide between trees. In fact, they can "fly" up to 100 yards (100 m).

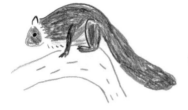

When they spread their arms and legs, their body is the size of a newspaper.

1 Round face with small ears—color ears and top half of face dark brown

CLOSE UP
Leave the edges of the face white.

2 Eyes, nose, and whiskers

3 Long curved lines extending horizontally from face

4 Draw a pocket shape, then add hands, feet, and a long tail

5 Use light lines to draw outline of arms, legs, and body

JAPANESE DWARF FLYING SQUIRREL

Scientific Name: *Pteromys momonga*

These diminutive squirrels have a skin membrane between their wrists and ankles, but not between their legs and tail. They can "fly" between 65–100 ft (20–30 m).

CLOSE UP
Go big! The eyes should be tall ovals.

1 Round face with small ears and an inverted triangle on top half of face—color ears and triangle light brown

2 Big eyes, a triangular nose, and whiskers

3 Long curved lines extending horizontally from face

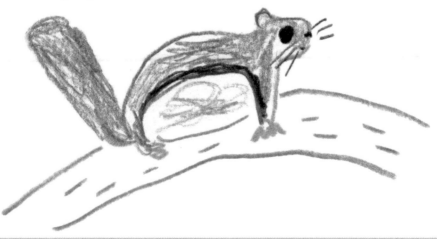

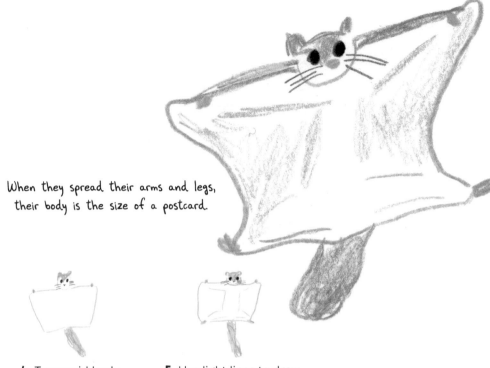

When they spread their arms and legs, their body is the size of a postcard.

4 Trapezoid body and long tail

5 Use light lines to draw outline of arms, legs, and body, then add feet

These nocturnal creatures live in cozy holes inside trees.

JAPANESE GIANT FLYING SQUIRREL

JAPANESE DWARF FLYING SQUIRREL

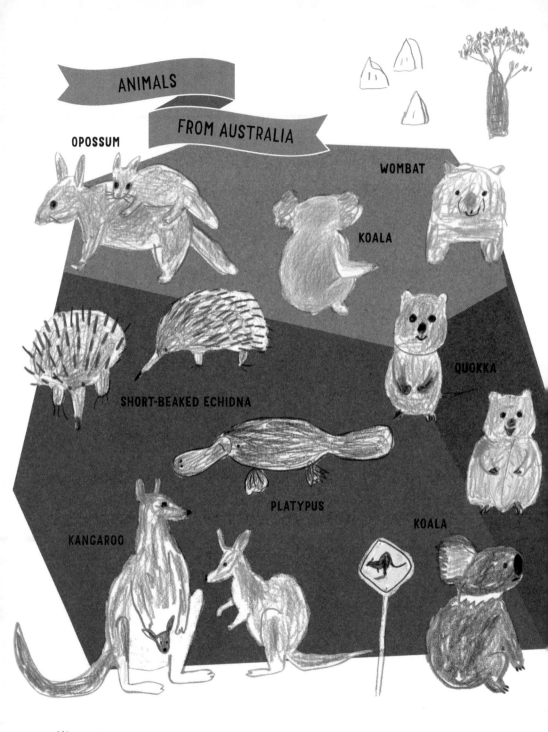

ANIMALS

FROM AUSTRALIA

OPOSSUM

WOMBAT

KOALA

SHORT-BEAKED ECHIDNA

QUOKKA

PLATYPUS

KOALA

KANGAROO

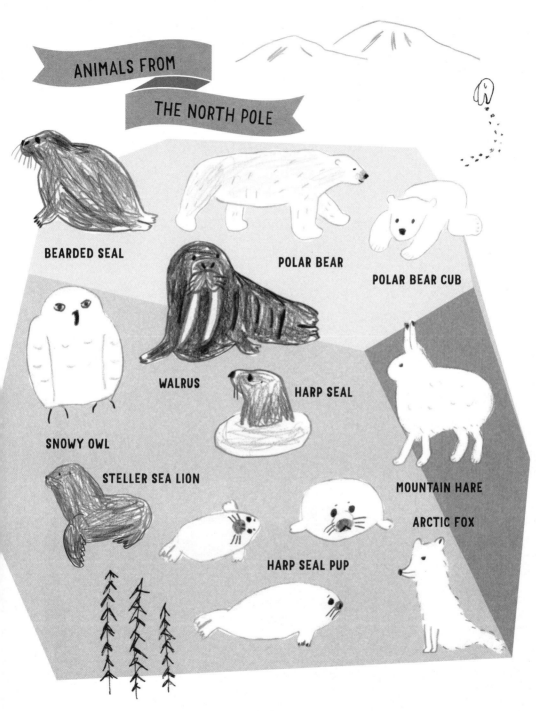

ANIMALS FROM
THE NORTH POLE

BEARDED SEAL

POLAR BEAR

POLAR BEAR CUB

WALRUS

HARP SEAL

SNOWY OWL

STELLER SEA LION

MOUNTAIN HARE

ARCTIC FOX

HARP SEAL PUP

RHINOCEROS

Scientific Name: *Rhinocerotidae*

Rhinos possess extremely thick skin that protects them from heat, predators, and brush. They are instantly recognizable by their distinctive horns, which are made of keratin, just like human hair and fingernails.

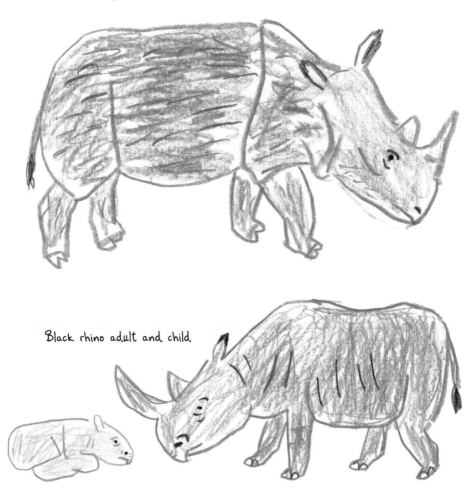

Black rhino adult and child

1 Leaflike ear and a long, curved horn

2 Small, triangular horn between ear and first horn

3 Large nostril, small mouth, and an eye positioned in middle of face

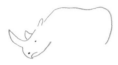 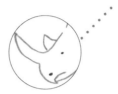

4 Large body, positioned higher than head with slight bumps for shoulder and rump

CLOSE UP
The upper lip should protrude slightly, except for white rhinos, which have square mouths.

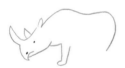 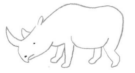 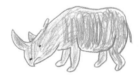

5 Thick front leg and foot

6 Square tummy and three more legs

7 Add tail and color gray or light brown

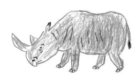

8 Add wrinkles around eyes, nose, and body and hair to tip of ear and tail

CLOSE UP
The ears are one of the only places rhinos have hair! Use dark brown to make the hair stand out against the gray skin.

Sumatran Rhino

This is the smallest (and hairiest!) rhino species. These rhinos are excellent swimmers and climbers.

Indian Rhino

This one-horned rhino has folds of armor-like skin covered with wart-like bumps.

Plates of skin shift as the rhino moves

Javan Rhinos

This rhino looks very similar to the Indian rhino, but is smaller. Many female Javan rhinos do not have horns.

Females may have a small knob on the nose or no horn at all.

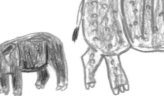

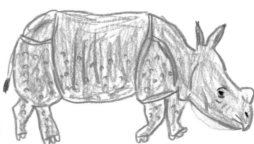

Black Rhinos

Despite their name, these rhinos are actually gray. They have two horns.

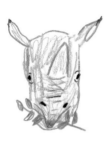

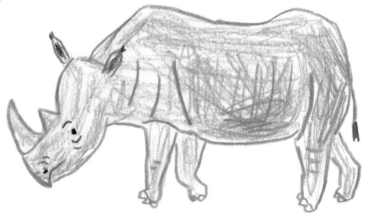

Pointed upper lip for eating leaves and fruit from tree branches

White Rhinos

White rhinos are actually gray too! They have two horns with the foremost horn being the most prominent. Their horns can grow up to 5 ft (1.5 m) long!

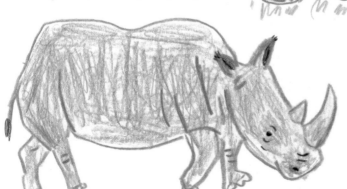

Square lips for eating grass

MEERKAT

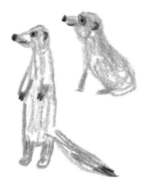

Scientific Name: *Suricata suricatta*

Meerkats are social animals who live in large groups.
The group works together to gather food, watch
for predators, and raise their young. They live
in underground burrows composed of multiple
chambers and tunnels.

They perch on their
back legs and watch
for predators.

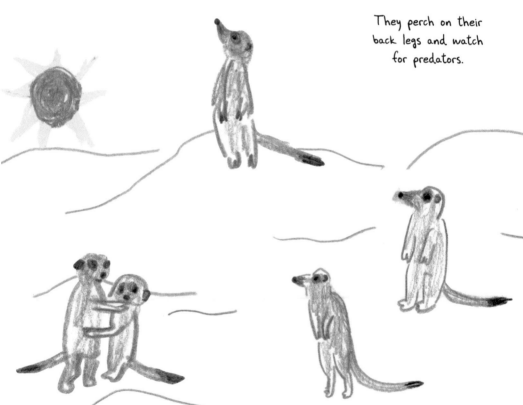

1 Pointed face and an arm extending down

2 Straight, skinny body with thick back legs

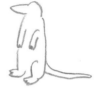

3 Long tail that touches ground

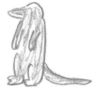

4 Color body brown

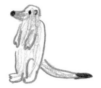

5 Add an eye, nose, and ear, then color tip of tail black

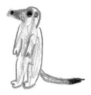

6 Add whiskers and black shading to facial features

Striped pattern on back

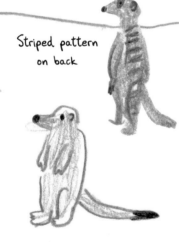

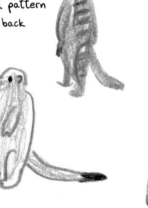

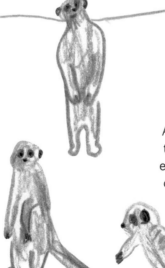

CLOSE UP
Add the shading to the nose, eye, and ear, leaving the rest of the face brown.

PRAIRIE DOG

Scientific Name: *Cynomys*

These animals may bark like dogs, but they're actually rodents. Prairie dogs live in huge underground burrows, called towns, that can contain thousands of residents!

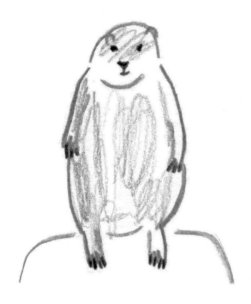

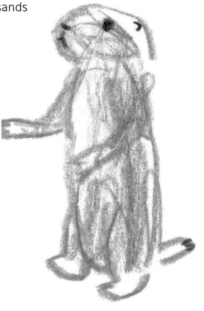

They have chubby bodies
with four short limbs.

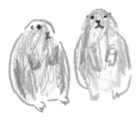

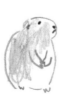

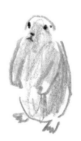

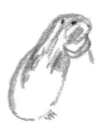

1 Semicircle head

2 Tiny ear

3 Arms that curve inward

4 Gentle curve for back

5 Add feet and a flat tail

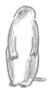

6 Color edges of body brown, leaving center white

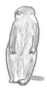

7 Color center of body gray

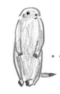

8 Add an eye, nose, and mouth, then color fingers, toes, and tip of tail black

CLOSE UP
The eyes should be slanted and the nose should be an inverted triangle.

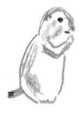
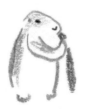

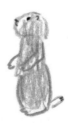
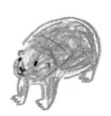

DOGS

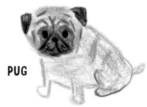

PUG

1 Triangle for ear and short
lines to outline head

2 Short front leg and a curled tail

3 Short horizontal lines across tail

4 Back leg beneath tail

I'm a chihuahua!

5 Add eye and nose

I'm a dachshund!

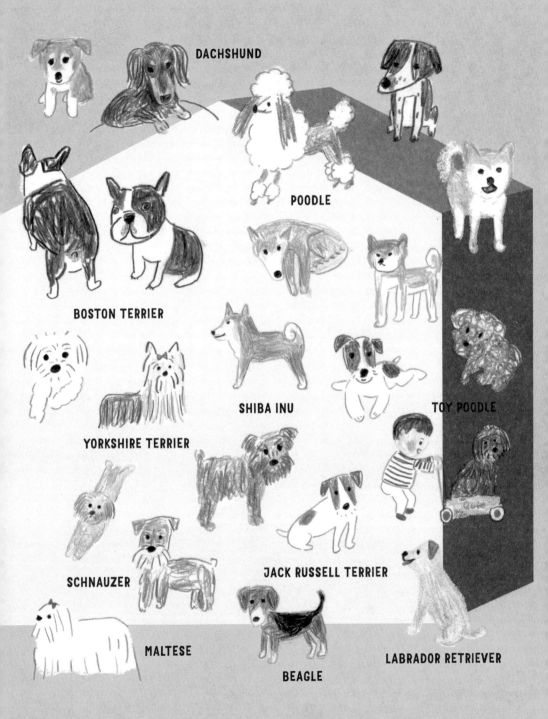

DACHSHUND

POODLE

BOSTON TERRIER

SHIBA INU

TOY POODLE

YORKSHIRE TERRIER

SCHNAUZER

JACK RUSSELL TERRIER

MALTESE

BEAGLE

LABRADOR RETRIEVER

CATS

1 Triangles for ears and a round chin

2 Curved lines for body

3 Short legs and a long tail

4 Big eyes and a nose

I'm a Siamese!

5 Color face and body
based on specific breed

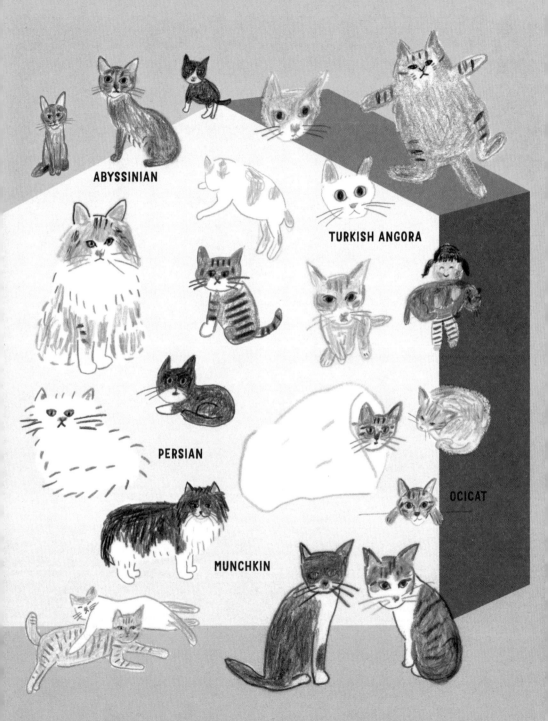

ABYSSINIAN

TURKISH ANGORA

PERSIAN

MUNCHKIN

OCICAT

HOUSE PETS

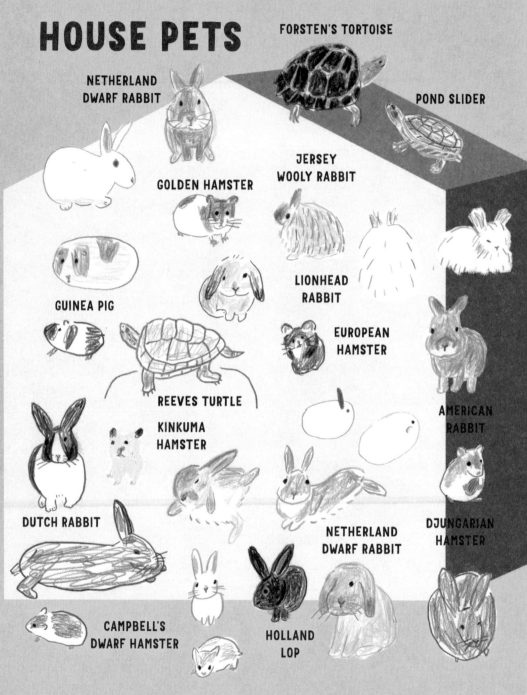

FORSTEN'S TORTOISE

POND SLIDER

NETHERLAND DWARF RABBIT

GOLDEN HAMSTER

JERSEY WOOLY RABBIT

LIONHEAD RABBIT

GUINEA PIG

EUROPEAN HAMSTER

AMERICAN RABBIT

REEVES TURTLE

KINKUMA HAMSTER

DUTCH RABBIT

NETHERLAND DWARF RABBIT

DJUNGARIAN HAMSTER

CAMPBELL'S DWARF HAMSTER

HOLLAND LOP

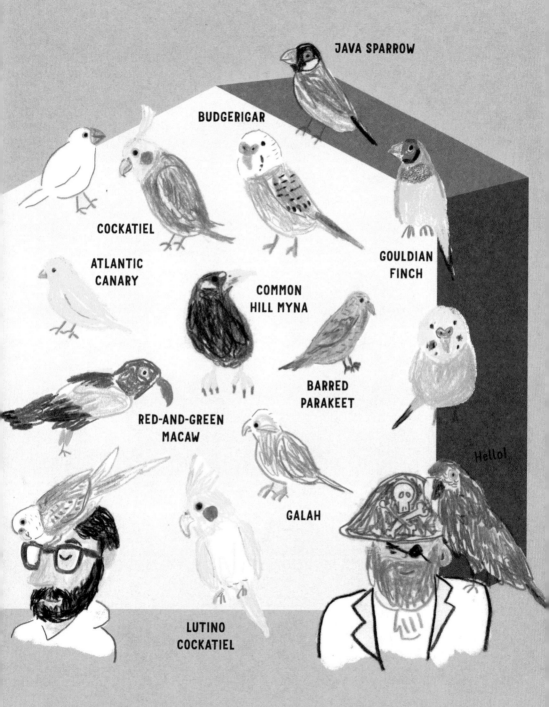

JAVA SPARROW

BUDGERIGAR

COCKATIEL

ATLANTIC CANARY

GOULDIAN FINCH

COMMON HILL MYNA

RED-AND-GREEN MACAW

BARRED PARAKEET

GALAH

LUTINO COCKATIEL

Hello!

BEAVER

Scientific Name: *Castor canadensis*

Beavers have reputations for being busy—and for good reason: They use branches and mud to build dams and lodges to create their ideal aquatic habitats. They're talented engineers!

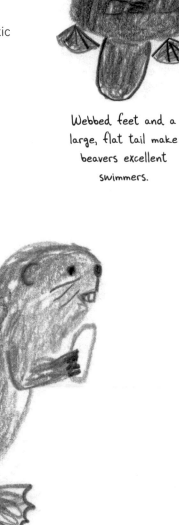

National symbol of Canada

Webbed feet and a large, flat tail make beavers excellent swimmers.

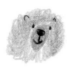

1 Gray oval with a black nose and mouth

2 Furry round head with small eyes and ears

3 Round body with short front arms

4 Color body brown

5 Five lines for each foot

6 Big, flat tail

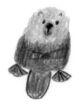

CLOSE UP
To make the webbed feet, draw the straight lines first, then connect with a curve.

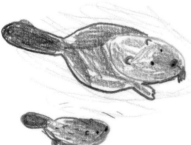

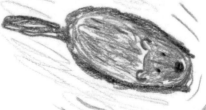

MOLE

Moles spend most of their lives in underground
tunnels. They aren't blind, but they have very poor
eyesight and rely heavily on their strong sense
of smell.

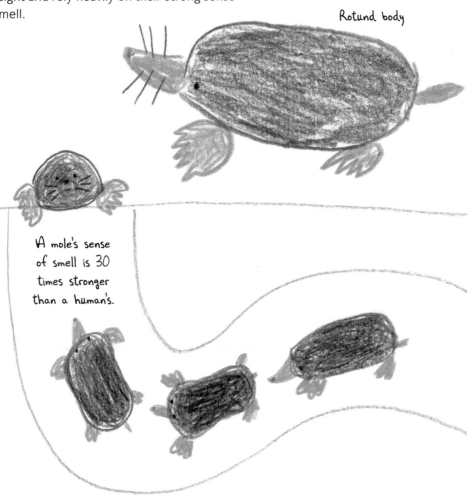

Rotund body

A mole's sense
of smell is 30
times stronger
than a human's.

1 Long, flat oval with a pink, pointy nose

2 Tulip-shaped feet and a short tail

CLOSE UP
The front feet should be larger than the back feet and should have large claws for digging.

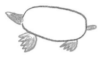 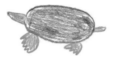 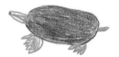

3 Color nose, feet, and tail pink

4 Color body brown

5 Add some darker fur

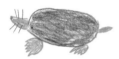

6 Add whiskers to nose and a tiny eye on side of head

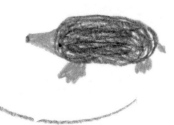 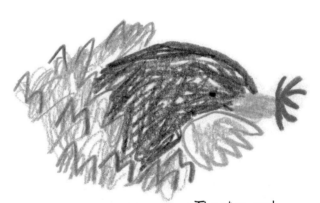

The star-nosed mole has 22 pink tentacles on its nose!

FOX

Scientific Name: *Vulpes vulpes*

Have you ever heard the phrase "sly as a fox?" Foxes are intelligent and inquisitive animals. Red foxes are identifiable by their bright orange fur, although a small percentage, known as silver foxes, have black and white coloring.

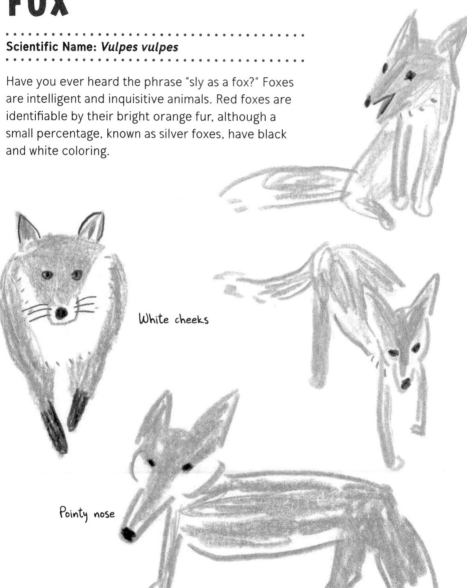

White cheeks

Pointy nose

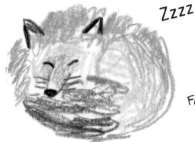

Zzzz

Foxes dig burrows called dens.

1 Large triangular ears and round cheeks

2 V shape for a pointy nose

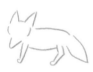

3 Short front leg and a long, slightly curved back

4 Short curve for tummy

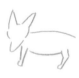

5 Back legs are slightly thicker than front

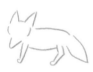

6 Voluminous tail with a pointy tip

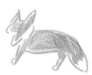

7 Color face and body orange, leaving cheeks and tip of tail white

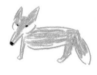

8 Add two eyes and a nose

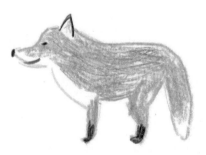

RACCOON DOG

Scientific Name: *Nyctereutes procyonoides*

Also known as a mangut or tanuki, the raccoon dog is native to East Asia. Although it closely resembles a raccoon, it's actually related to foxes, wolves, and domesticated dogs.

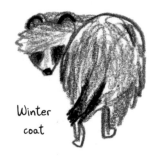

Winter coat

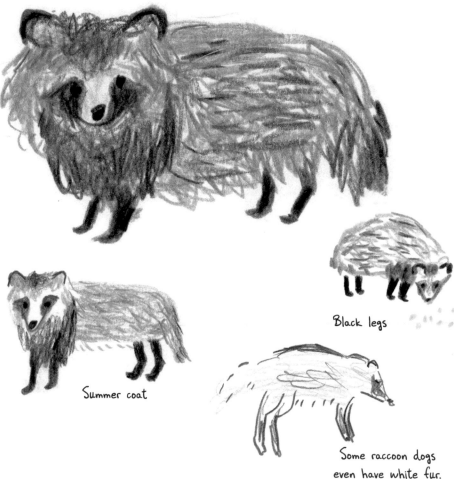

Black legs

Summer coat

Some raccoon dogs even have white fur.

1 Round ears and a pointy face

2 Short dashed lines for fur around face

3 Dashed lines for underside and tail, then a solid curve for back

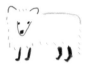

4 Add four skinny legs, eyes, and a nose

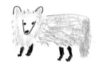

5 Color body with light lines, then add a large, fluffy tail

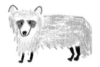

6 Black triangular patches around eyes

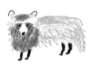

7 Shade forehead and neck with dark brown or black

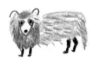

8 Add some darker lines to the body to capture fluffiness of fur

Hello

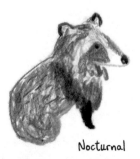

Nocturnal

In Japan, many restaurants have statues of tanuki at their entrances to bring good luck.

BAT

RING-TAILED
LEMUR

AYE-AYE

JAPANESE
MARTEN

RACCOON DOG

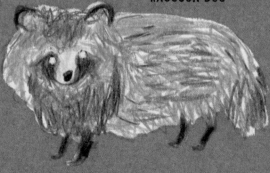

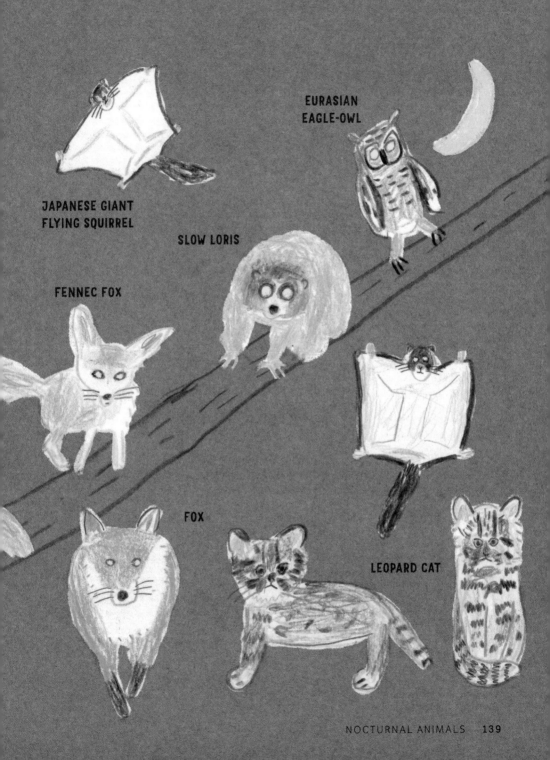

JAPANESE GIANT
FLYING SQUIRREL

EURASIAN
EAGLE-OWL

SLOW LORIS

FENNEC FOX

FOX

LEOPARD CAT

CHAMELEON

Scientific Name: *Chamaeleonidae*

Chameleons are famous for their ability to change color, but it's a misconception that they can change to match their surroundings. A chameleon can move each eye separately and has 360° vision.

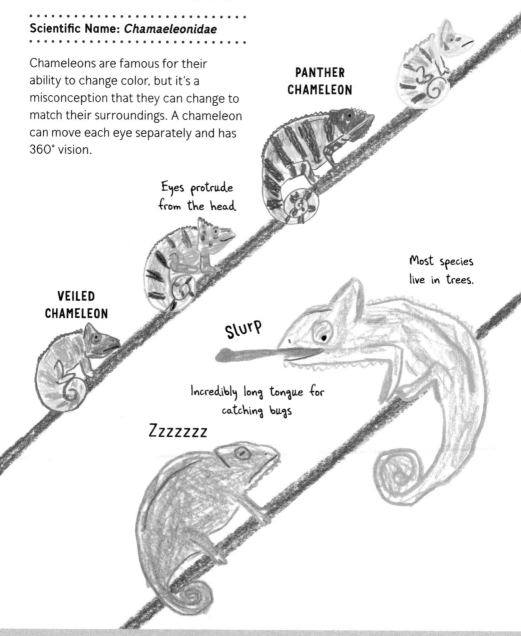

PANTHER CHAMELEON

Eyes protrude from the head

VEILED CHAMELEON

Most species live in trees.

Slurp

Incredibly long tongue for catching bugs

Zzzzzzz

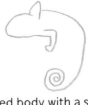

1 Large triangle for face and small triangle for ear with front leg bent at a 90° angle

2 Curved body with a spiral tail

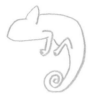

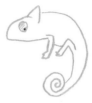

3 Connect tail to rest of body, then add a back leg

4 Big circle for eye with a small black dot and lines for eyelid

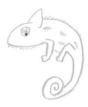

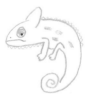

5 Zigzags along back and chin and stripes on body

6 Big mouth and small dot for nostril

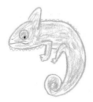

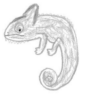

7 Color in rest of body

8 Add some darker shading to forehead and ear

LIZARD

There are over 6,000 species of lizards and they live all over the world, except Antarctica. A lizard's scaly skin does not grow as it ages. Instead, the lizard will shed its old skin and regrow a new one.

Long, curved tail that's thinner at tip

JAPANESE SKINK

When threatened, these lizards can squirt blood from their eyes!

HORNED LIZARD

GECKO

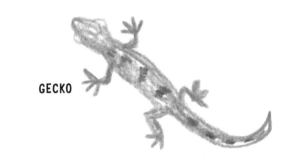

1 Thin oval for body

2 Add some stripes

3 Color body, being careful not to cover stripes

4 Add some darker stripes to body and tail

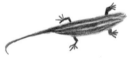

5 Draw front legs facing forward and rear legs facing backward

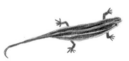

6 Black dots for eyes

FROG

Scientific Name: *Anura*

Frogs are amphibians, meaning they live both on land and in water. Even though frogs have lungs, they also breathe through their skin, which must be kept wet. Their famous croaking noises are an effort to attract a mate.

Frogs are born as tadpoles.

Zzzzzzz

ribbit

ribbit

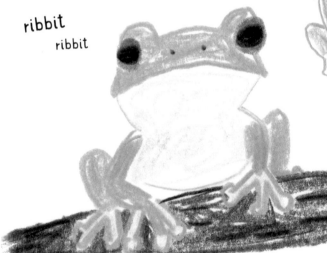

AUSTRALIAN GREEN TREE FROG

SURINAM HORNED FROG

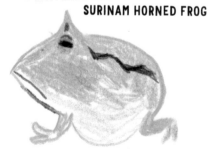

A Japanese tree frog is the same size a 500 yen coin—that's about the size of a US quarter!

1 Round face with a protruding eye and a smooth curve for body

2 Thick leg

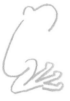 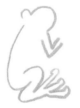

3 Foot has long toes

4 Skinny arm

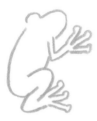 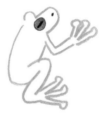

5 Long fingers

6 Big, round eye with a horizontal pupil

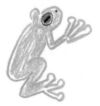 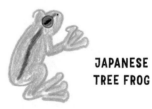

JAPANESE TREE FROG

7 Color body green

8 Add a stripe

MEMBERS OF THE
FROG FAMILY

STRAWBERRY POISON DART FROG

POISON DART FROGS

DARK-SPOTTED FROG

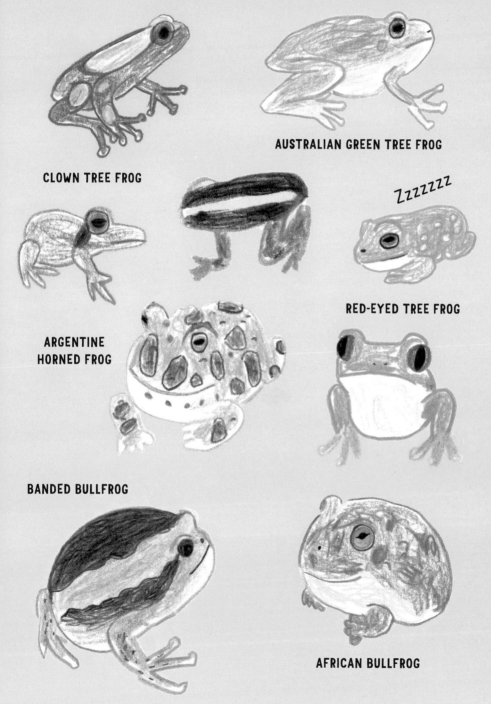

CLOWN TREE FROG

AUSTRALIAN GREEN TREE FROG

Zzzzzzz

RED-EYED TREE FROG

ARGENTINE
HORNED FROG

BANDED BULLFROG

AFRICAN BULLFROG

TERRITORIAL
ANIMALS

Animals can be very territorial,
sometimes disputes are unavoidable.
Here are some action poses of animals
defending their turf.

SOUTHERN TAMANDUA

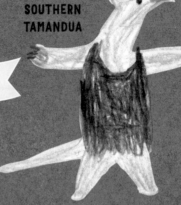

Ahhh

Snarl

Gyuuuuu!

TASMANIAN DEVIL

SUGAR GLIDER

Grrrrr

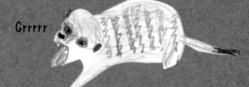

ASIAN BLACK BEAR

MEERKAT

Rooooooar

Moooooo

HIPPOPOTAMUS

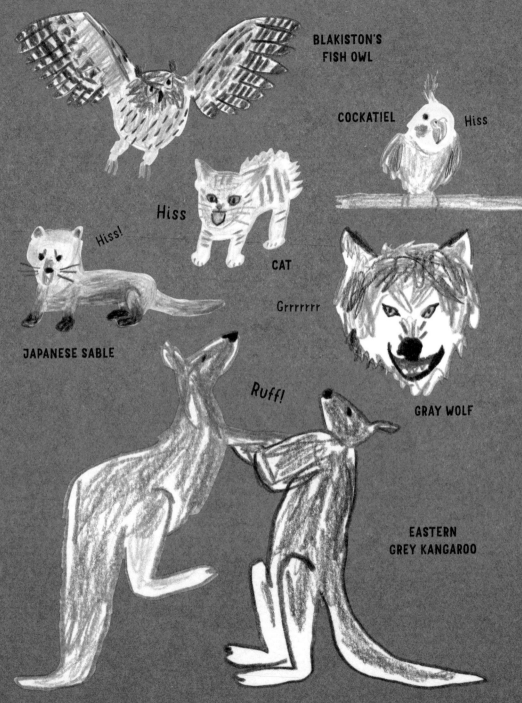

BLAKISTON'S
FISH OWL

COCKATIEL Hiss

Hiss

CAT

Hiss!

Grrrrrrr

JAPANESE SABLE

GRAY WOLF

Ruff!

EASTERN
GREY KANGAROO

OSTRICH

Scientific Name: *Struthio camelus*

The ostrich is the largest bird in the world. It's so heavy that it's unable to fly! However, ostriches are pretty fast runners.

Ostriches are the only bird with two toes. Only their inner toes have claws.

OSTRICH EGG
20-30 times larger than a chicken egg

1 Inverted triangle for beak

2 Petal shape for head

3 Position eyes on side of head and add nostrils to beak

CLOSE UP
The eyes have long lashes.

4 Long, skinny neck beneath beak

5 Dark circle for body and long, skinny legs

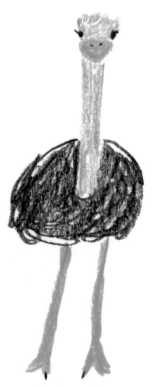

Males have black and white feathers, while females have grayish brown feathers.

EMU

Scientific Name: *Dromaius novaehollandiae*

Emus are the second largest bird in the world. Like ostriches, emus are flightless, but they're fast runners. When on the run, an emu's stride can reach 9 ft (2.7 m) long.

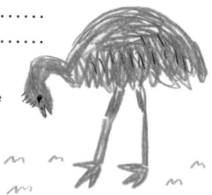

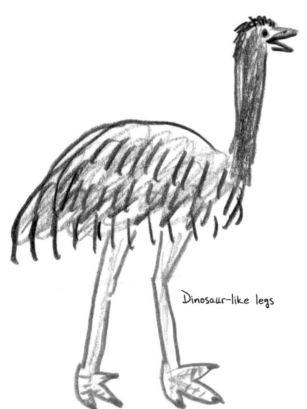

Dinosaur-like legs

EMU EGG

12 times larger than a chicken egg

Striking blue-green color

1 Sideways M for beak

2 Small dot on upper beak for nostril

3 Large circle for eye

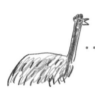

4 Add a black dot to center of circle and some fluffy feathers on top of head

5 Long, skinny neck

6 Round body filled with short vertical lines

7 Color body

CLOSE UP
An emu's wings are smaller than an ostrich's, so the body shouldn't be as voluminous.

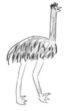

8 Long, thick legs with three-toed feet

Red eyes

In New Zealand, emu feathers are good luck charms.

FLAMINGO

Scientific Name: *Phoenicopterus*

Flamingos' brilliant pink color actually come from the algae and crustaceans the birds eat. In fact, a flamingo feather will quickly lose its color once shed.

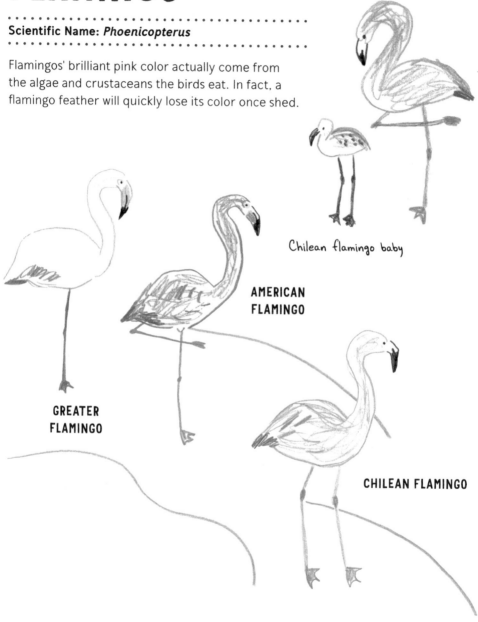

Chilean flamingo baby

AMERICAN FLAMINGO

GREATER FLAMINGO

CHILEAN FLAMINGO

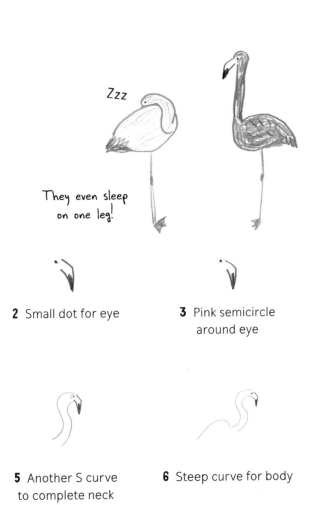

Zzz

They even sleep on one leg!

1 Sharp beak pointing downward with a black tip

2 Small dot for eye

3 Pink semicircle around eye

4 S-shaped curve for head and neck

5 Another S curve to complete neck

6 Steep curve for body

7 Complete lemon-shaped body

8 Color body pink and shade tip of tail dark pink

9 Thin legs with knees and webbed feet

CRANE

Scientific Name: *Gruidae*

Known for their graceful and elaborate dances, cranes are considered sacred in many cultures. There are fifteen different crane species.

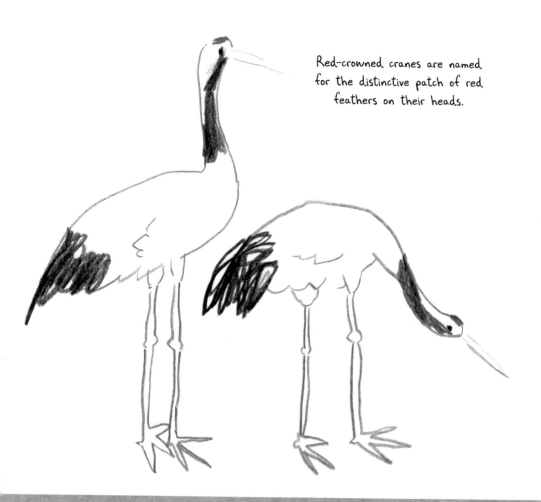

Red-crowned cranes are named for the distinctive patch of red feathers on their heads.

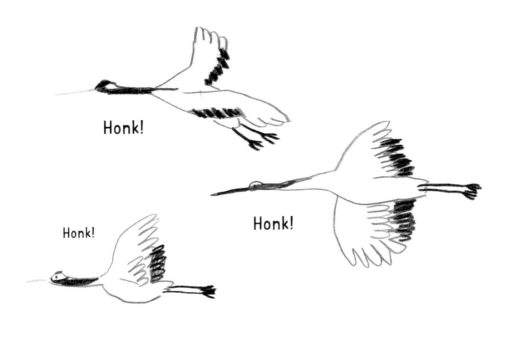

Honk!

Honk!

Honk!

1 Long, straight beak and a small red patch

2 Neck and body shaped like the numeral 2

3 Small eye and long black feathers on rump

4 Color neck black, leaving area around eye white

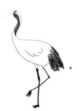

5 Skinny legs with three-toed feet

CLOSE UP
The upper portions of the legs are covered in feathers—leave these white.

SWAN

Scientific Name: *Cygnus*

Swans rank among the heaviest birds capable of flight. They're symbols of elegance and grace, but they can be quite aggressive, especially when defending their nests.

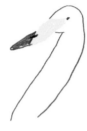

WHOOPER SWAN
Mostly yellow bill with a black tip

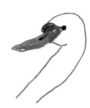

TUNDRA SWAN
Black bump at the base of the bill

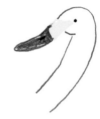

MUTE SWAN
Black bill with yellow spot at base

Many parks have swan-shaped boats available for rent!

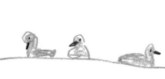

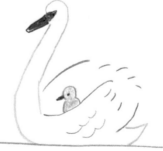

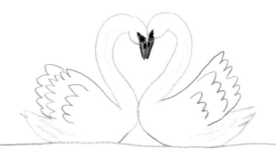

Mute swans curve their necks into a heart as part of their courtship ritual!

1 Long, thin bill with an oval nostril

2 Small, round head and a long, curved neck

3 Lemon-shaped body

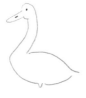

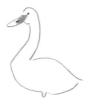

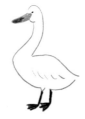

4 Round eye

5 Orange area between eye and nostril

6 Black legs and tip of bill

CLOSE UP
To make the webbed feet, first draw three straight lines, then connect with concave curves.

PEAFOWL

Scientific Name: *Pavo cristatus*

Often referred to as "peacocks" (technically, only males are peacocks), these pheasants are famous for their beautiful blue and green feathers. Males fan and display their long trains of vibrantly colored feathers to attract females.

Some peafowl have white feathers.

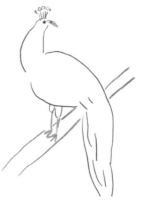

All baby peafowl are born brown. Males develop their colored feathers around six months.

Believe it or not, they can actually fly!

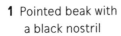

1 Pointed beak with a black nostril

2 Oval face with a black eye intersected by a diagonal blue line

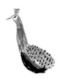

3 Draw a long neck, then color neck and face blue, leaving area around eye white

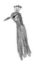

4 Crest of pin-shaped feathers on top of head

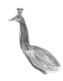

5 Oval body that slopes downward

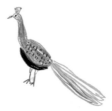

6 Black dots on back for feathers and black underside

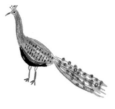

7 Feathered tail longer than body

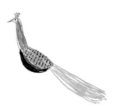

8 Add some darker feathers to tail

9 Decorative oval patterns on feathers

CLOSE UP

For a quick version of a peacock's spots, draw blue and black ovals. For a more detailed version, add some brown shading, then outline with short green lines.

MEMBERS OF THE BIRD FAMILY

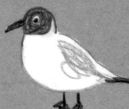

**BLACK-HEADED GULL
(SUMMER COAT)**

BARN SWALLOW

ORIENTAL STORK

**COMMON
KINGFISHER**

LONG-TAILED TIT

**JAPANESE
BUSH WARBLER**

**JAPANESE
WHITE-EYE**

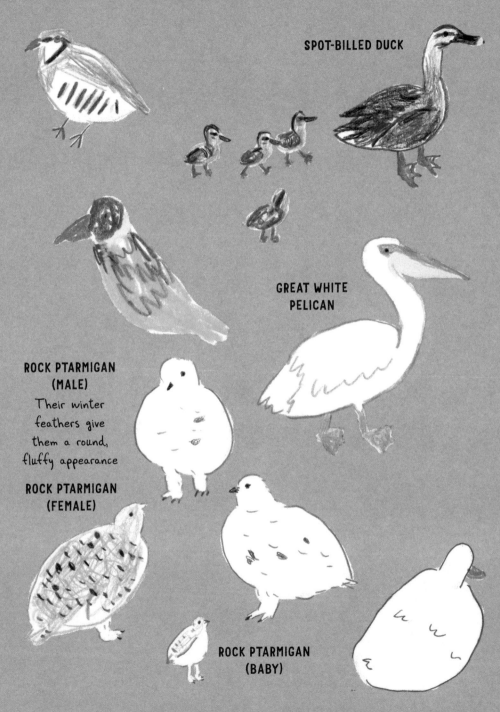

SPOT-BILLED DUCK

GREAT WHITE PELICAN

ROCK PTARMIGAN (MALE)

Their winter feathers give them a round, fluffy appearance

ROCK PTARMIGAN (FEMALE)

ROCK PTARMIGAN (BABY)

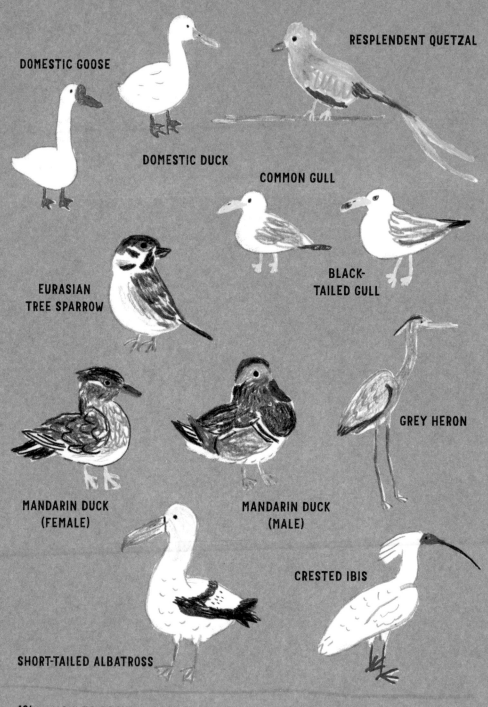

DOMESTIC GOOSE

DOMESTIC DUCK

RESPLENDENT QUETZAL

COMMON GULL

BLACK-
TAILED GULL

EURASIAN
TREE SPARROW

MANDARIN DUCK
(FEMALE)

MANDARIN DUCK
(MALE)

GREY HERON

CRESTED IBIS

SHORT-TAILED ALBATROSS

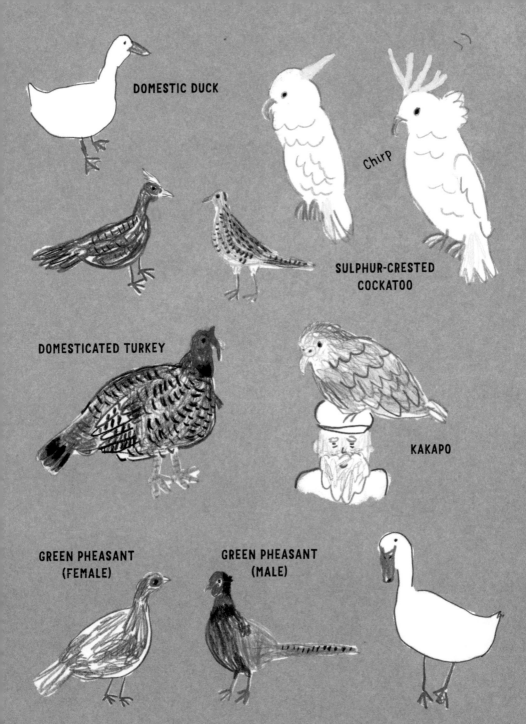

DOMESTIC DUCK

Chirp

SULPHUR-CRESTED
COCKATOO

DOMESTICATED TURKEY

KAKAPO

GREEN PHEASANT
(FEMALE)

GREEN PHEASANT
(MALE)

OWL

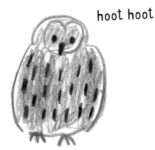

hoot hoot

Scientific Name: *Strigiformes*

With extremely powerful hearing, stealthy, nearly silent flight capabilities, and sharp talons, owls are excellent hunters. They can even rotate their heads 270°!

Barn Owl

1 Heart with a flat bottom

2 Arch above heart

3 Long, skinny, leaf-shaped wings

4 Color forehead and wings brown, then add short legs

5 Inverted triangle for beak

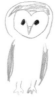

6 Big, round eyes

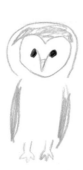

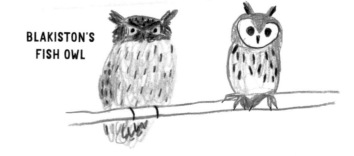

BLAKISTON'S FISH OWL

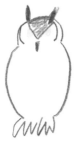

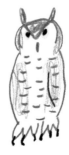

1 Wide inverted triangle for forehead

2 Two leaf-shaped feathers for horns and a pointy beak

3 Round cheeks and big, yellow eyes

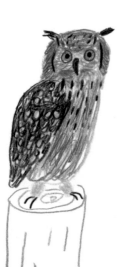

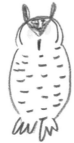

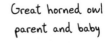

4 Oval body with big feet

5 Short lines for feather pattern

6 Shade wings and face, then add black pupils to eyes and long talons to feet

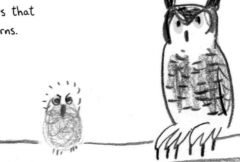

EURASIAN EAGLE-OWL

Some species have special feathers that resemble horns.

Great horned owl parent and baby

SHOEBILL

Scientific Name: *Balaeniceps rex*

Named for its large and distinctive shoe-shaped beak, the shoebill is a fearsome predator. It will stand motionless for hours, then ambush unsuspecting prey.

They're usually silent, but they're known for bill-clattering—a loud noise made when birds clap their bills together.

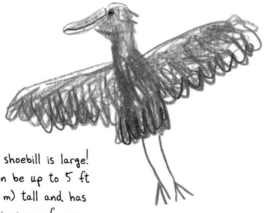

The shoebill is large! It can be up to 5 ft (1.5 m) tall and has a wingspan of more than 7 ft (2 m).

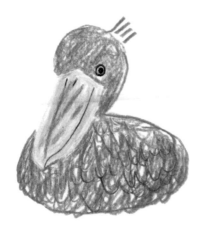

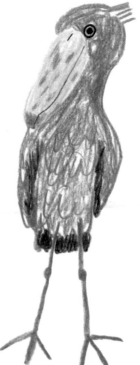

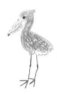

1 Large, almond-shaped bill

2 Add a curved line and a nostril

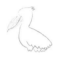

3 Curved head and body with wavy lines for wing feathers

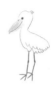

4 Double circle for eye and long, thin legs

5 Color body gray and add some gray to tip of bill

CLOSE UP
Add some darker shading to the bill to give it a mottled effect.

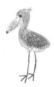

6 Add wavy lines to body for fluffy feathers

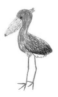

7 Color feather tips dark blue

WHITE-TAILED
EAGLE

ANDEAN CONDOR

HARRIS'S HAWK

WHITE-BACKED
VULTURE

BATELEUR

SEA OTTER

Scientific Name: *Enhydra lutris*

With webbed feet and water-repellent fur, these adorable creatures are designed for life in the ocean. Often seen floating on their backs, otters even sleep in the water! They'll hold hands with each other or wrap themselves in seaweed to keep from floating away!

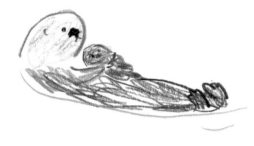

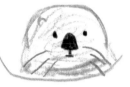

Big, triangular nose

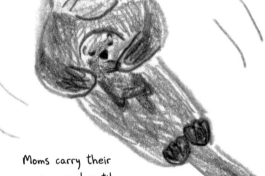

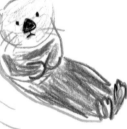

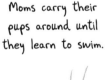

Moms carry their pups around until they learn to swim.

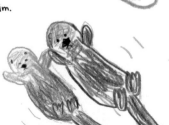

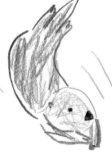

 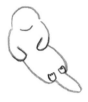

1 Round head and two curved arms

2 Straight body and tail

3 Tulip-shaped feet

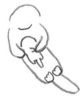 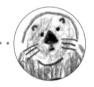 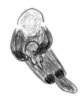

4 Baby on mom's tummy

5 Color baby brown

6 Color mom's body gray, then shade hands and feet darker

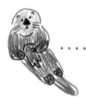 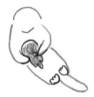 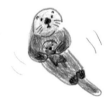

7 Add ears, eyes, a triangular nose, a small mouth, and whiskers

CLOSE UP
The nose should be the focal point of the face. The mouth is much smaller in comparison.

8 Add facial features to baby

Zzz

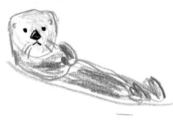 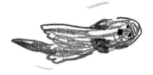 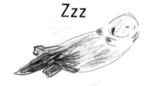

HEDGEHOG

Scientific Name: *Erinaceus europaeus*

Hedgehogs are named for the piglike grunting noises they make when hunting for food among hedges and other brush. They are instantly recognizable by their coat of sharp spines and will curl up into a prickly ball if attacked.

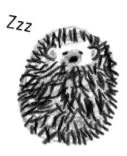

Zzz

Hedgehogs will curl up into a ball to protect themselves.

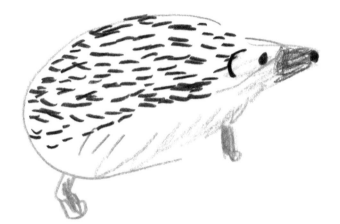

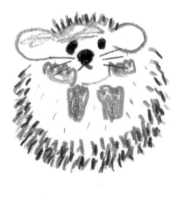

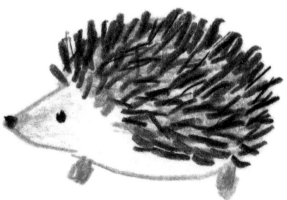

1 Pointed face and a small, round ear

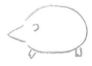

2 Big, oval body and short little legs

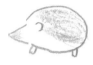

3 Color nose and body gray, leaving tummy white

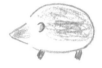

4 Color nose tip, ear, and legs pink

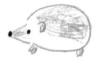

5 Large black circle for nose and an eye positioned halfway between nose and ear

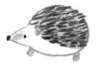

6 Add lots of dark lines to back for spines

CLOSE UP
The spines should extend from the ear across the entire back. Leave the tummy white.

ANIMALS WITH SIMILAR DEFENSE MECHANISMS

The Brazilian three-banded armadillo can roll itself into a ball.

A porcupine has quills that will stick into a predator's skin.

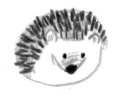

POLAR BEAR

. .
Scientific Name: *Ursus maritimus*
. .

As residents of the freezing cold Arctic, polar bears have a coat of thick fur to keep them warm. But did you know that under their fur, a polar bear's skin is actually black? Their black skin helps them to soak in the warming rays of the sun.

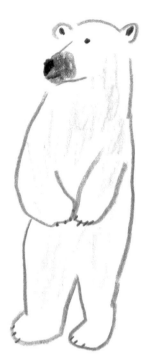

Thick fur keeps the polar bear warm in the Arctic

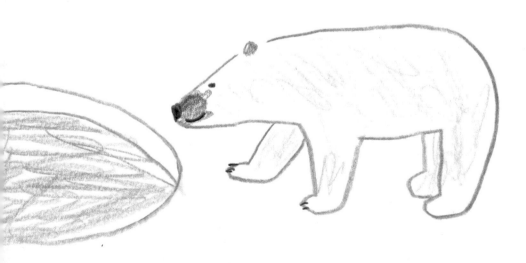

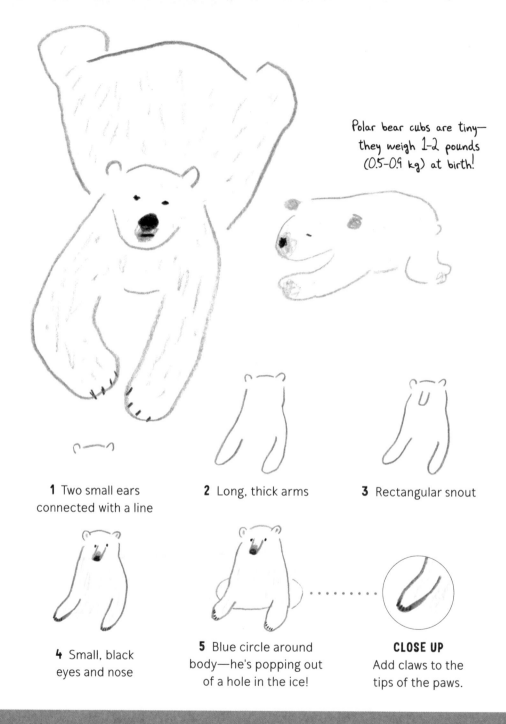

Polar bear cubs are tiny—they weigh 1-2 pounds (0.5-0.9 kg) at birth!

1 Two small ears connected with a line

2 Long, thick arms

3 Rectangular snout

4 Small, black eyes and nose

5 Blue circle around body—he's popping out of a hole in the ice!

CLOSE UP
Add claws to the tips of the paws.

SLOTH

Scientific Name: *Folivora*

Sloths have a reputation for being lazy—they sleep up to 20 hours a day and barely move when they're awake. In fact, they're so sedentary that algae grows on their fur!

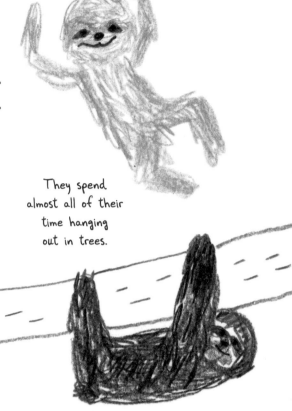

They spend almost all of their time hanging out in trees.

Dark patches of fur around the eyes give the sloth a sad look.

The algae on their bodies serves as camouflage and protects them against predators.

To walk, they dig their front claws into the dirt and drag themselves across the ground.

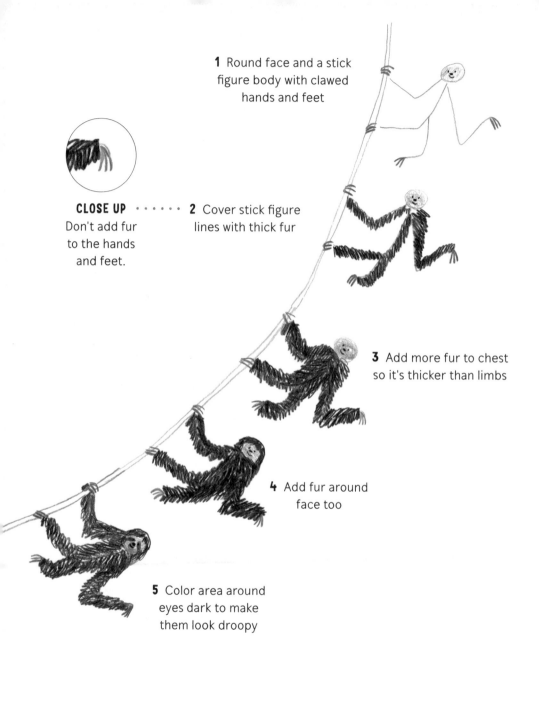

1 Round face and a stick figure body with clawed hands and feet

CLOSE UP · · · · · · **2** Cover stick figure
Don't add fur lines with thick fur
to the hands
and feet.

3 Add more fur to chest so it's thicker than limbs

4 Add fur around face too

5 Color area around eyes dark to make them look droopy

SEA LION

Scientific Name: _Otariinae_

. .

Sea lions, seals, and walruses belong to a group of flipper-footed marine mammals called pinnipeds. Sea lions and seals look very similar, but you can tell them apart by their ears: Sea lions have small external ear flaps, while seals just have tiny openings on their heads.

Sea lions are intelligent and can be trained to perform various tricks.

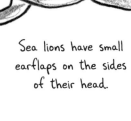

Sea lions have small earflaps on the sides of their head.

They use their front flippers to propel themselves through the water.

 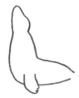

1 Head shaped like a Japanese bullet train

2 Straight back, big chest, and a zig-zag shaped front flipper that touches ground

3 Lower body positioned at a right angle

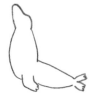

4 Two zigzag-shaped hind flippers

5 Color gray

6 Add an eye, ear, and nose

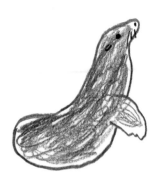

 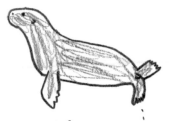

Sea lions can rotate their hind flippers and walk like other four-legged animals.

Fur Seal

More closely related to sea lions than to seals, these animals have longer flippers and luxurious coats of fur.

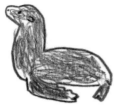

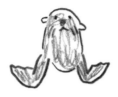

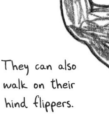

They can also walk on their hind flippers.

Steller Sea Lion

This is the largest species of sea lion. They can weigh more than one ton!

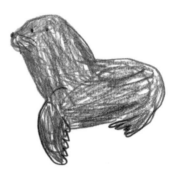

South American Sea Lion

These dark brown sea lions have shorter, wider muzzles.

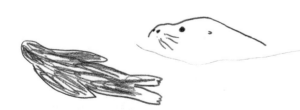

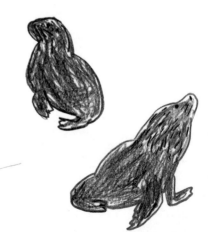

SIMILAR ANIMALS

Walrus

Their iconic tusks are actually long canine teeth!

Check out that mustache!

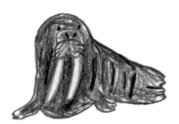

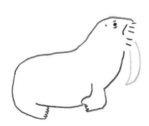

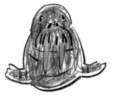

Earless Seals

Also known as true seals, this group has ear holes, but no external ears. They have short front flippers and flop their bellies to move on land.

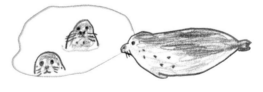

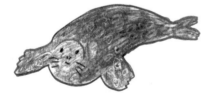

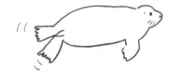

Harbor seals (parent and baby)

Spotted seals (adult and babies)

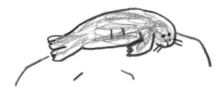

Harp seal babies are born white

PENGUIN

Scientific Name: *Spheniscidae*

Penguins are flightless birds whose wings have evolved into flippers. Most penguins live in the Southern Hemisphere.

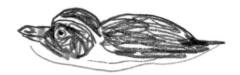
Swimming

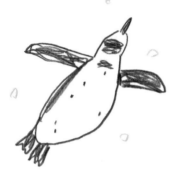

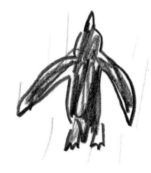

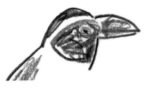

Front view

Rear view

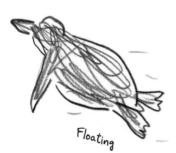
Floating

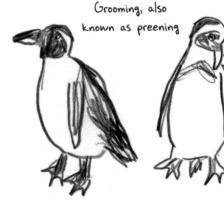
Grooming, also known as preening

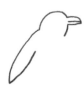

1 Round head with a long, thin beak

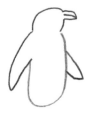

2 Wing with a pointed tip

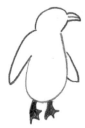

3 Round body and another wing

Two feet facing in same direction

4

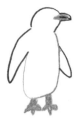

5 Color beak and feet orange

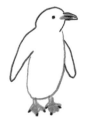

6 Add claws and an eye

I'm a gentoo penguin

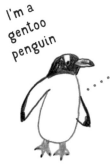

Color face and tips of wings black

CLOSE UP
Leave a small white patch around the eye. The white patch extends across the top of the head too!

I'm a Humboldt penguin

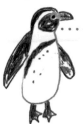

Color face and wings black

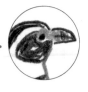

CLOSE UP
Shade the area around the eye and part of the beak red.

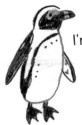

I'm an African penguin

Color face, wings, and part of the chest black—the African penguin's face and chest should be whiter than the Humboldt penguin's.

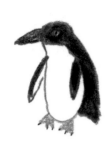

LITTLE BLUE PENGUIN

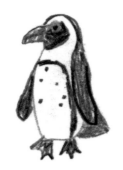

AFRICAN PENGUIN

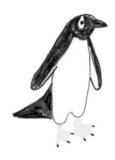

GENTOO PENGUIN

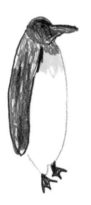

KING PENGUIN

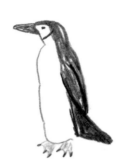

CHINSTRAP PENGUIN

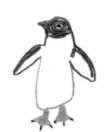

ADÉLIE PENGUIN

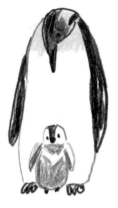

EMPEROR PENGUIN

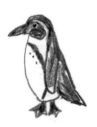

**HUMBOLDT
PENGUIN**

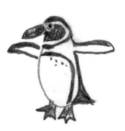

**MAGELLANIC
PENGUIN**

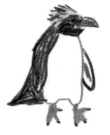

**SOUTHERN
ROCKHOPPER
PENGUIN**

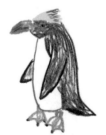

**MACARONI
PENGUIN**

CROCODILE

Scientific Name: *Crocodylinae*

Crocodiles are fierce predators who lurk beneath the water's surface, just waiting to attack. As reptiles, their bodies are covered in scaly armor.

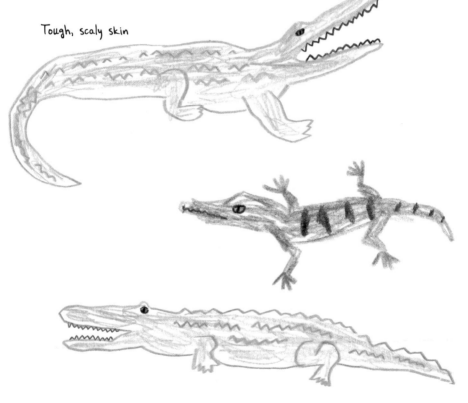

Tough, scaly skin

Pupil looks like a vertical slit

1 Long, thin snout and a round, protruding eye

2 Lower jaw is slightly shorter than snout with space between the two for teeth

3 Bumpy line for back

4 Curved tail that tapers to a point

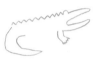

5 Short front leg beneath lower jaw

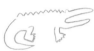

6 Short back leg next to tail

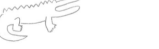

7 Connect legs with a slightly rounded tummy

8 Add wavy lines to center of body and tail

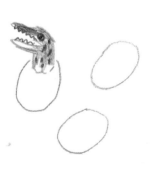

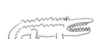

9 Add a pupil to eye and fill mouth with sharp teeth

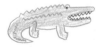

10 Color body using rough, messy lines

PLATYPUS

Scientific Name: *Ornithorhynchus anatinus*

Platypuses are one of only two mammals that lay eggs. These extremely unique creatures look like a combination between a duck, otter, and beaver.

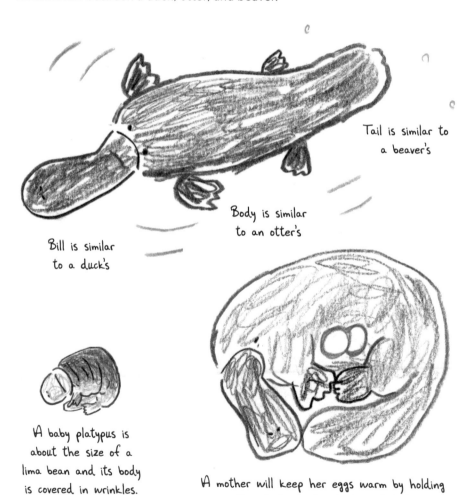

Tail is similar to a beaver's

Body is similar to an otter's

Bill is similar to a duck's

A baby platypus is about the size of a lima bean and its body is covered in wrinkles.

A mother will keep her eggs warm by holding them between her body and tail.

1 Footprint-shaped face

CLOSE UP
The bill is flat, so it should appear this way even when the platypus is drawn from an angle.

2 Add two dots to end of the bill for nostrils and a curved line to top

 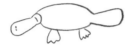

3 Draw an oval body and a long, flat tail

4 Big, webbed feet that spread out from body

5 Add some lines to feet and draw an eye

6 Color body brown and bill and feet gray

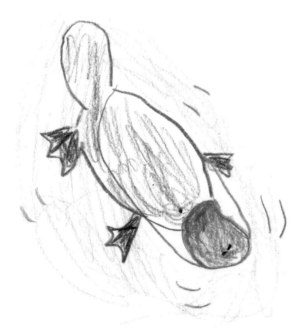

RARE ANIMALS

Okapi

Although they look like zebras, okapi are actually related to giraffes. They live in the dense rainforest of Central Africa.

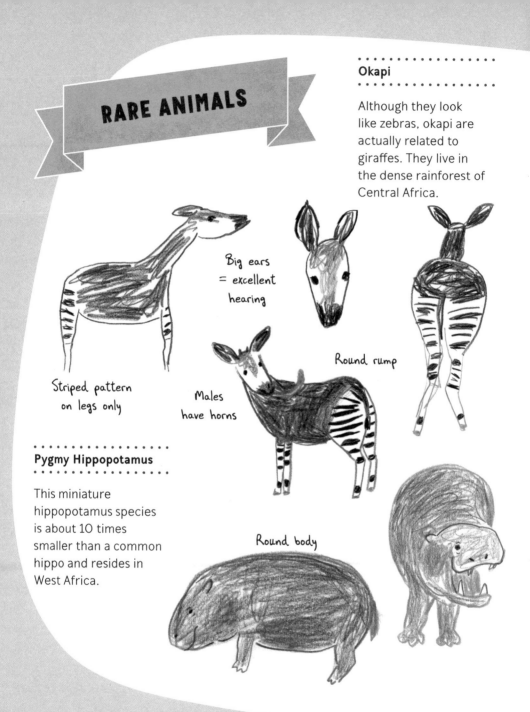

Big ears
= excellent
hearing

Round rump

Striped pattern
on legs only

Males
have horns

Pygmy Hippopotamus

This miniature hippopotamus species is about 10 times smaller than a common hippo and resides in West Africa.

Round body

Bongo

This large antelope lives in the forests of Africa. Both males and females have horns.

Spiral horns that twist 1-1.5 times

10- 15 white lines on body

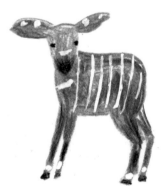

Unique facial markings

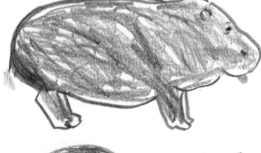

Eyes don't protrude from head like a common hippo

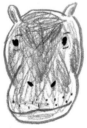

Brimming with creative inspiration, how-to projects, and useful information to enrich your everyday life, Quarto Knows is a favorite destination for those pursuing their interests and passions. Visit our site and dig deeper with our books into your area of interest: Quarto Creates, Quarto Cooks, Quarto Homes, Quarto Lives, Quarto Drives, Quarto Explores, Quarto Gifts, or Quarto Kids.

Inspiring | Educating | Creating | Entertaining

First published in the United States of America in 2017 by
Quarry Books, an imprint of
The Quarto Group
100 Cummings Center
Suite 265-D
Beverly, Massachusetts 01915-6101
Telephone: (978) 282-9590
Fax: (978) 283-2742
QuartoKnows.com

Quarry Books titles are also available at discount for retail, wholesale, promotional, and bulk purchase. For details, contact the Special Sales Manager by email at specialsales@quarto.com or by mail at The Quarto Group, Attn: Special Sales Manager, 100 Cummings Center, Suite 265-D, Beverly, MA 01915-6101. USA.

10 9 8 7 6 5

ISBN: 978-1-63159-376-5

Translator: Ai Toyoda Jirka
English Language Editor: Lindsay Fair

Printed in China

Chika Miyata studied illustration in college and has worked in the advertising industry. She has exhibited her work in galleries throughout Japan and won many awards. She is also the author of *How to Draw Almost Everything*.

Visit her website at www.miyatachika.com

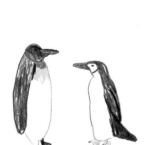

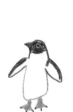

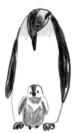